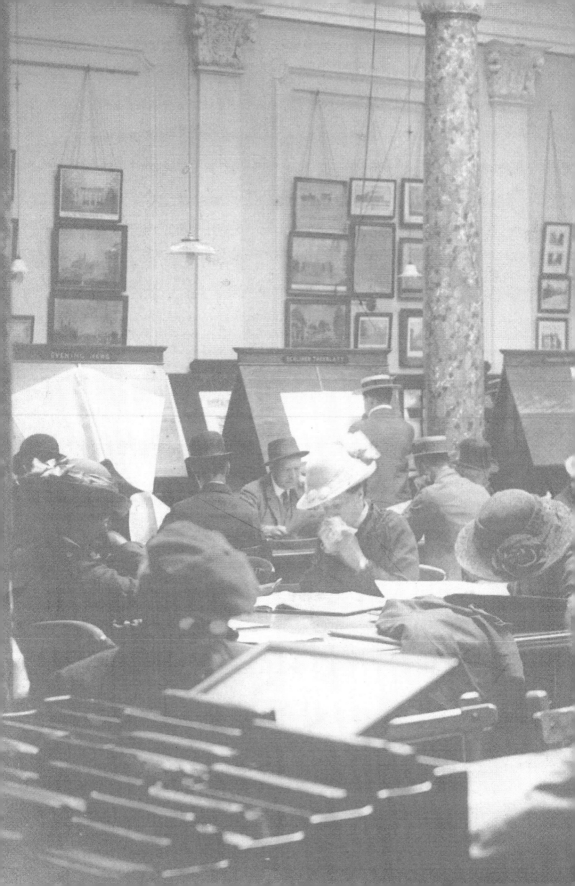

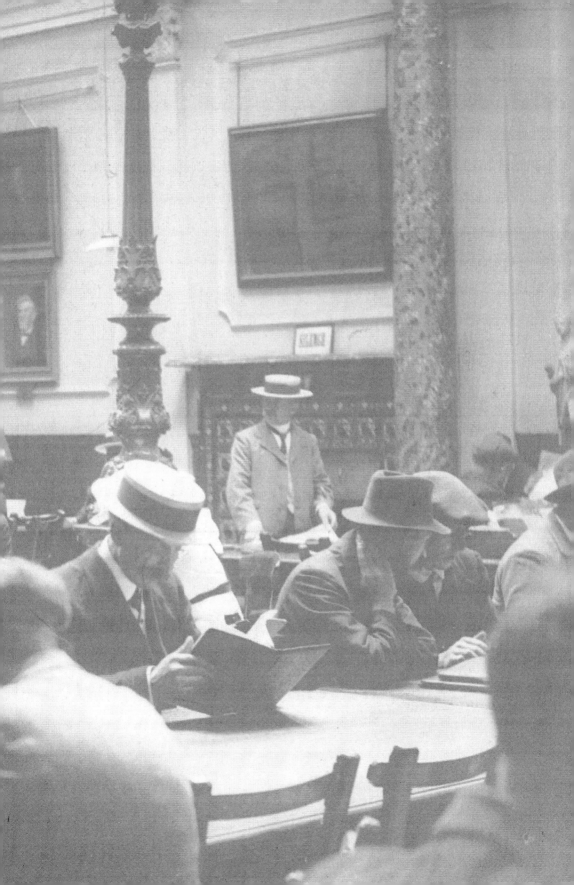

CAMBRIDGE
PAST & PRESENT

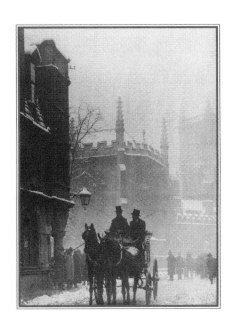

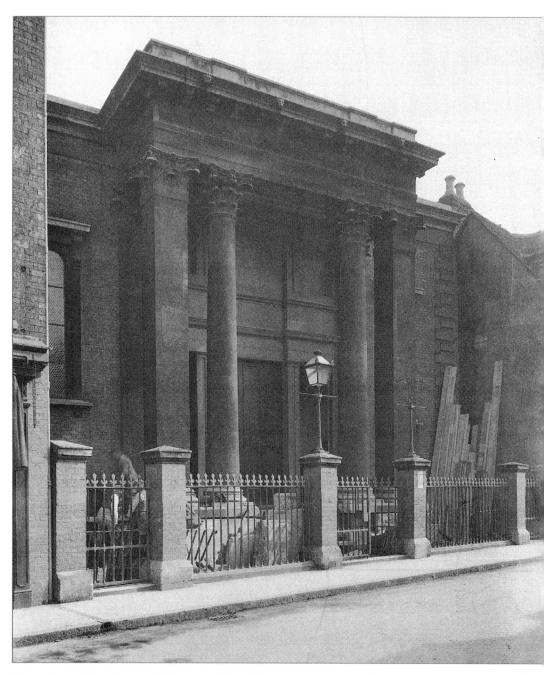

Wesley Chapel, Hobson Street, *c.* 1910. It was built in 1849 after the previous premises in Green Street became too small for the 300-strong congregation. It was rebuilt again in 1894 but within eighteen years it had been sold to the county council (see page 6) and a new church was constructed next to Christ's Pieces. (*Cambridgeshire Collection*)

CAMBRIDGE
PAST & PRESENT

JOHN DURRANT

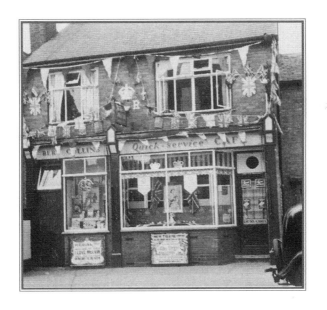

First published in the United Kingdom, in 2000 by Sutton Publishing Limited

This new paperback edition first published in 2007 by
Sutton Publishing

Reprinted in 2010 by
The History Press
The Mill, Brimscombe Port,
Stroud, Gloucestershire, GL5 2QG
www.thehistorypress.co.uk

Reprinted 2013

British Library Cataloguing in Publication Data
A catalogue record for this book is available from the British Library.

ISBN 978-0-7509-4908-8

Front endpaper: Cambridge Library, *c.* 1900.
Back endpaper: Parker's Piece, 2000. (*Tony Jedrej*)
Half title page: The final journey: A hearse in Trinity Street, 1908. A well-known
Cambridge theatre used this wintry scene on the front of its Christmas cards, without
realising the vehicle's function. (*Cambridgeshire Collection*)
Title page: Fast food English style: Bert Collins's Quick Service Café, East Road, 1953.
(*Cambridgeshire Collection*)

> *Dedicated to the late Bill McManus, a dear friend and clay pipe collector,*
> *and to all those who research, write, photograph, record and save*
> *local history. Without them there would not be a wealth of material*
> *and ideas upon which the public can draw.*

Typeset in Photina.
Typesetting and origination by
Sutton Publishing.
Printed and bound in England.

Contents

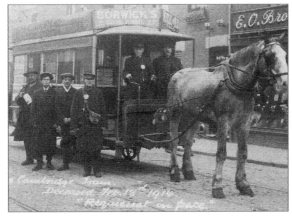

The Cambridge tram, 1914. Its speed provoked a local saying – 'If you are in a hurry, walk. If not take a tram!' (*Cambridgeshire Collection*)

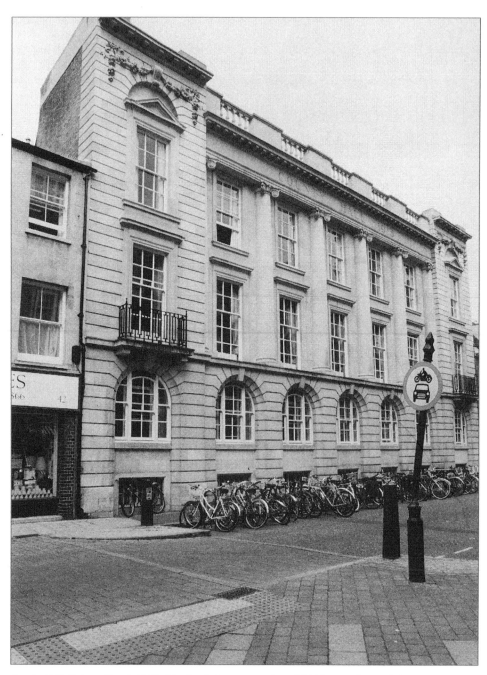

County Hall, Hobson Street, 2000. The Local Government Act of 1888 created a need for more extensive offices but within a few years of opening in 1913 these too were inadequate. The county built new offices, back up the hill, in 1931–2. (*Tony Jedrej*)

Cambridge: An Introduction

On King's Parade in Cambridge the low wall that runs nearly the length of the street makes a popular informal resting place. The university faces the city in what the casual observer may be forgiven for thinking a timeless view, unchanged over hundreds of years. Indeed, some things haven't altered. King's Chapel has dominated the area since its construction in the fifteenth century, but not everything has remained the same. Alongside the chapel is the Wilkins Screen fronted by a manicured lawn. All this was once domestic buildings which were not finally cleared until the early nineteenth century. Similarly, on the town side of the wall, Great St Mary's, the University Church, was also once surrounded by small-scale shops and houses that reached up to its very doors.

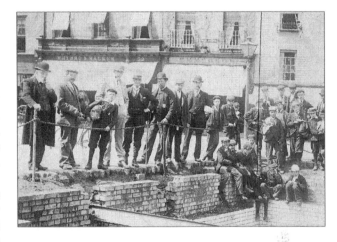

Form a queue and wait for an opening: Market Square underground toilets under construction, 1902. Note the fashion and etiquette of hats: working men in flat caps, schoolboy with cap, foremen and supervisors in bowlers, and a gentleman could wear a boater or whatever he liked. (*Cambridgeshire Collection*)

The large spaces around our medieval buildings are a relatively modern creation and give us a false impression of the past.

To an observer sitting on that low wall, King's Chapel remains breathtakingly impressive and continues to command the Cambridge skyline. The awe experienced when looking at this beautiful building is reinforced when fifteenth-century and modern construction methods are compared; bucket and spade, hammer and chisel versus the mechanisation of the modern age. If, given our experiences, we remain enthralled by this structure, then how much more would the feudal peasantry and traders have held it in awe, and not just the building and its founders but the beliefs and rituals for which it was built?

History is like a three-dimensional jigsaw puzzle. The further back in time one goes the fewer pieces are available. What one sees in the past is dependent upon the century in which one stands. We look back and forward through the eyes and experiences of the present. The perception of a lost heritage helps us to save what remains but can also make

us fearful for our future. What are now regarded as historic buildings often replaced others of similar merit. Many of the Cambridge colleges were constructed from the building materials reclaimed from the dissolved monastic houses. Even the once great Cambridge Castle wasn't immune from such a fate. Some of our finest buildings were built in an undemocratic age which had little regard for old buildings and saw them as merely a source of recyclable materials. Today, armed with conservation areas and preservation orders, we salvage what we can but the constraints of wanting to save the past from destruction can bring inertia: we can't live forever in a museum. A photograph on page 67 shows an old man sitting under a tree. What would his comments be about the modern age? Would he have damned those new-fangled inventions and constructions of the Victorians and harkened back to the idyllic days of his youth? What is old was once new and what is new (if it survives) will soon be old.

This book is not a history of Cambridge. There are others that tell the full story of the city. What will be found among the comparisons of old and new pictures are some surprises about individual buildings and a broad historical perspective on the intriguing development of the urban land-scape. A greater understanding of our built heritage will provide an open window into our future.

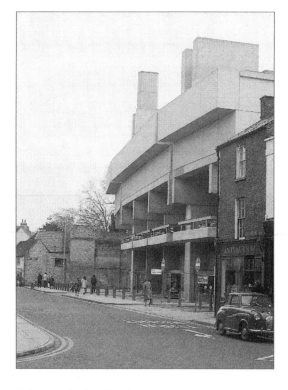

King Street, 1977. Built by Christ's College in 1970 this student accommodation block turned its back on the street. The frontage is an interesting, stepped, south-facing terrace in complete contrast to the harsh concrete environment to the rear with ground-floor shops and first-floor car parking. (*Norman Mason-Smith*)

The sanitised and semi-romantic modern view of the physical relics of past ages is fatally flawed without the benefit of the historical context in which they were created. The survival of well-repaired timber-framed country cottages can give a mis-impression of the quality of life of the occupants. The knowledge that a family of thirteen on or below the poverty line could have lived in two rooms without running water or adequate heating will extinguish a rosy view of the past. Similarly, the modernisation of our urban terraces with central heating, sanitation and labour-saving food preparation processes by people of far higher income and social status than earlier inhabitants has created a built legacy which is somewhat more pleasant than the original reality. The removal of some of the worst properties has further skewed our view of those that have survived. Nor are the grander buildings immune from such treatment. Jesus College saw baths as unnecessary until the 1920s

because undergraduates were only up at the university for ten weeks at a time!

The invention of photography in the mid-nineteenth century generated vast quantities of images from both professional and amateur practitioners and these swelled public collections. But we must deal with these pictures cautiously. The camera never lies but photographs can distort the truth: no picture should be accepted uncritically without accompanying information. Furthermore, the absence of pictures can be as important as what is available. Commercial photographers understandably rarely found a market for views of the seamier parts of the town.

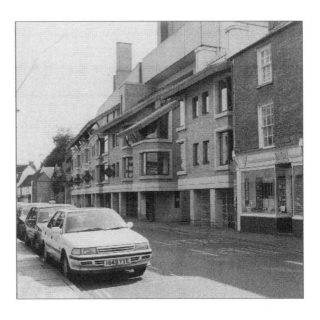

Until the introduction of colour in the 1950s our pictorial view of history tends to be monochrome. When confronted with black-and-white stills, and a childhood diet of old films it is difficult to picture the past as awash with colour. Despite the availability of some coloured illustrations and tinted or painted photographs, this book is confined to the use of black-and-white pictures. The use of modern colour stills would also have given a very unbalanced contrasting view in favour of the present.

King Street, 2000. Refaced with brick in 1994, the shop fronts and additional accommodation soften and enhance the street scene. (*Tony Jedrej*)

Cambridge Past & Present has been a long time in the making. It began in my childhood when as a curious youngster I wandered the city wondering why 'they' were demolishing attractive old buildings. Those same questions were reborn years later when as a city councillor I discovered boxes of slides lying unused in the Guildhall. I was already producing slide-shows and these new finds, alongside old pictures from the Cambridgeshire Collection, became the basis for a new series of displays. Several years later they were used in a video, produced with The Junction Digital Studio and artist Catherine Watling, and entitled *Changing Cambridge*, for the city's millennium celebrations; it premiered to 30,000 people on Parker's Piece.

* * *

Cambridge is known throughout the world for its university. Without it, this would probably have remained just a small county market town. The Romans constructed a fort in 43 AD, displacing an earlier Belgic

settlement in the area of Castle Hill and protecting the crossing point which became Magdalen Bridge. Waves of Saxons and early Danish invaders were followed by the Normans who fortified the castle, but by then the centre of town had moved to the south bank of the Cam.

The origins of the university are somewhat obscure but the most colourful story is one of a group of wandering students who arrived by chance in the small town in 1209 after fleeing Oxford following the death of a prostitute. As time went on both universities became more fanciful in their claims to the title of elder and it was said that this rivalry gave rise to the first of the varsity sports – the art of lying.

The townspeople may well have marvelled at their new visitors who were at the forefront of the thirteenth-century 'knowledge revolution'. These strangers brought a welcome increase in trade but no one realised that as the colleges grew, so would their ambitions to control local affairs. The ensuing struggles between the university and the town were embodied in the personae of the vice-chancellor and the mayor. One local historian has called this the 800 Years War. It was a war of legal words rather than physical conflict for, despite the violence of much of English history, quiet Cambridge saw no great battles. However, the townspeople did riot against the poll tax in 1381 and during the sacking of one college an aged crone is reputed to have cried, 'Away with the learning of all the clerks!' Religious controversies abounded and individuals were martyred. Two were burnt at the stake, but not until two years after their death!

The university gave Cambridge a unique urban landscape. From humble hostels, the colleges grew in wealth and power with the support of the Crown and abundant endowments, particularly from widows. Although women could found colleges they couldn't collect a degree until 1947! The appetite for expansion into the town was unsatisfied by the absorption of dissolved monastic houses in the sixteenth century. The most notorious land acquisition was the demolition and clearance of part of the trading quarter and the closure of the main road in Milne Street to create King's and its chapel.

The comparative stability of the later Elizabethan period allowed the encroachment of buildings beyond the old defence line of the King's Ditch but, like today's Green Belt, the open-field system continued to act as a barrier to any significant change. Not until the early nineteenth century did the enclosures of the West and East Fields provide land for expansion and this influenced the pattern of urban growth up to the present day. Many small owners in the East Fields didn't take long to realise their capital value by building poor-quality speculative housing. Larger owners and institutions could afford to wait longer and tended to build bigger and better-quality developments. The colleges were the main beneficiaries in the West Fields but the expansion in both student numbers and facilities

was partly accommodated in an accumulation of town centre sites. West Cambridge became a future land bank which is currently undergoing an explosion in development.

The nineteenth century saw a large growth and greater sophistication in retailing, which resulted in a mid- and late Victorian development of the town centre. Specialist shops met the needs of the well-to-do academic market and general department stores like Eaden Lilley and Joshua Taylor's grew and grew.

In the mid-twentieth century the fashion for even larger scale retail centres swept aside some of the Victorian inheritance, including five listed buildings demolished to make way for Lion Yard. The obsession of modern investors with developing retail boxes resulted in the destruction of the Fitzroy Street area for the Grafton Centre shopping mall, and later the multi-screen cinema.

The existence of Lion Yard and the Grafton Centre, with their potential for expansion, enabled Cambridge to resist the lure of an out- or edge-of-town shopping centre, but casualties may occur, with possible loss of another local landmark, the former Co-operative Store in nearby Burleigh Street. Adjacent to Lion Yard, which has itself received a make-over, a huge extension to Cambridge's shopping area is in preparation, including a major arcade and a replacement for the Robert Sayle branch of John Lewis, the only department store remaining in the historic city. Shopping is now a major leisure activity. Insulted by Napoleon as a nation of shopkeepers, we have become a nation of shoppers two centuries later.

The physical growth of Cambridge in the nineteenth century was accentuated and distorted by the arrival of the railway in 1845. Both the population and local agricultural industry began to gravitate towards the station, resulting in the slow decline and then death of river freight. With the introduction of modern sanitation, the Cam was converted from an open sewer into a genteel pleasure ground for academics; punts and rowing eights replaced rude barges and even ruder bargees. Cambridge, unlike Oxford, was to remain largely an academic haven. It resisted the encroachment of heavy industry apart from the now redundant extraction of chalk for cement manufacture. Scientific instrument companies were the forerunners of the modern hi-tech and bio-tech sectors connected to academic research.

The city, as it became in 1951, is now a pre-eminent focus of the 'knowledge revolution' and is nicknamed 'Silicon Fen', a small-scale rival to Silicon Valley. The Cambridge Phenomenon (or 'Fenomenon') has created demand for both housing and employment land but the restrictive Green Belt has forced development into what are termed the necklace villages and beyond. Without adequate public transport, more people drive to work across the Green Belt than currently live and work in the

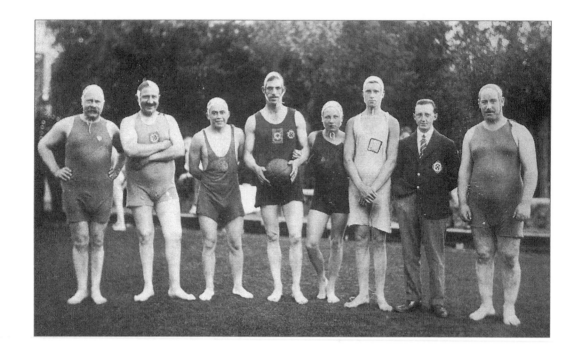

city. Cambridge now faces a dilemma: can the city grow and still maintain its charm and close proximity to open spaces? Will the Green Belt destroy growth or will it force development into the city and destroy our heritage? Or should growth be resisted and development be encouraged to go elsewhere?

Nothing is certain except uncertainty. Both the city and university must adapt to the changing circumstances of the time. Cambridge is not a huge museum and standing still is not an option. If this book is revised in 2050, how much will remain?

Understanding the past is an aid to mapping the future. We may not learn all the lessons but wisdom can be found in unexpected places. A hotel colleague once told me that you can't divine your fate without first understanding your past; it's like building a house without foundations. Readers should make their own judgements on what they see here. I hope it will influence their view of the future.

Indecent exposure: water polo players in the 1930s. The lady who donated this picture was somewhat embarrassed by its content and swore the author to secrecy as to its origin. (*Cambridgeshire Collection*)

Market Square &
Peas Hill

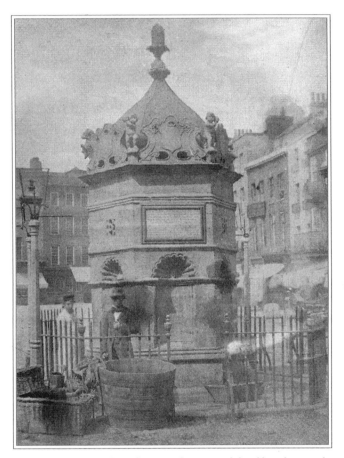

Hobson's Conduit, Market Hill, 1856. This is one of the oldest photographs
of Cambridge. Thomas Hobson was the first person to let out hackney horses,
and bequeathed to the English language the famous phrase 'Hobson's Choice,
that or none', derived from his practice of selecting the most rested horse for
a prospective client. He was among the donors who funded the first supply of
public freshwater to the town in 1614. The Conduit Head was removed to a
new site when the corporation cleared fire-damaged buildings to create the
present square. This was not the only structure on Market Hill as Cambridge
also had a Market Cross which after several reconstructions was finally removed
in 1786. (*Cambridgeshire Collection*)

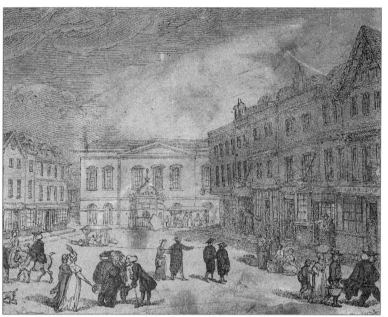

Market Hill and the old Shire Hall, 1801. By the 1960s every building in this view had been demolished, apart from a short range on the left, including the premises with the balcony. Cambridge has been compared to Rome in that both cities have seven hills, although ours are a little less apparent. It is possible that once significant gradients have been levelled by centuries of rubbish deposits during the Middle Ages. However, it is also reputed that 'hill' was the word used to describe an area of flat open space. Only in Cambridge where May balls are held in June would one have the problem of discerning the difference between traditional and flat hills! In the late Victorian period local people still used the expression, 'I wonder the hill don't fall down upon you' (*Cambridgeshire Collection*)

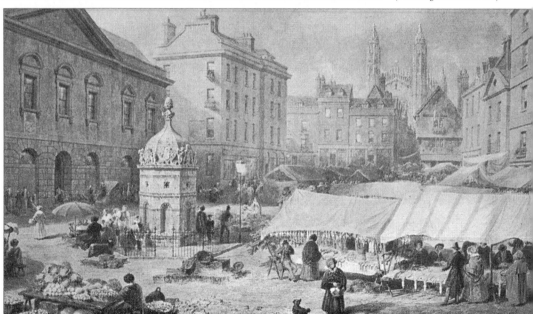

Market Hill, 1840. After the Great Fire of 1849 destroyed much of the block to the right, the corporation cleared the remnants to form the modern square, extinguishing another Cambridge street in the process – Warwick Street, once known as Pump or Well Lane. The parishioners of Great St Mary's were relieved that they no longer had a view through the altar windows into the backs of the houses, because what went on in the bedrooms did not always accord with the divine service (*Cambridgeshire Collection*)

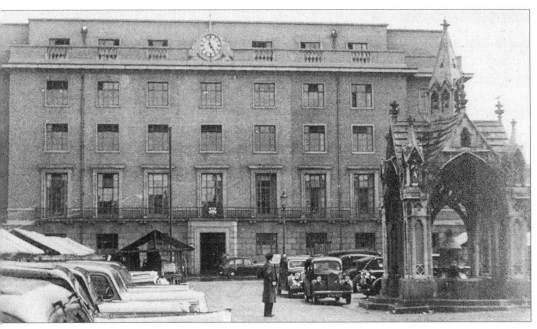

The Guildhall and fountain, 1950. Late Victorian plans were rejected and it took a further forty years before the council approved the replacement of the old 1747 Shire House and the 1782 Guildhall which stood behind. Constructed in two parts, this purpose-built municipal headquarters is now a listed building. Unfortunately the bricks didn't quite match and even today you can still see the join. The fountain, which supplanted the conduit, was of less robust construction and was seen to be swaying in the breeze in 1953. It was dismantled, leaving only the base, and each carefully numbered piece was stored safely and never seen again! Only the four corner statues survived and can now be seen in the garden of the Folk Museum. (*Cambridgeshire Collection*)

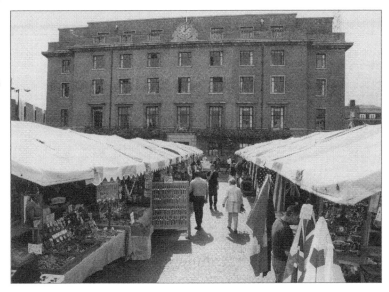

The Guildhall and market, 2000. 'If you are not important then don't come in' – that's the message projected by this grand 1930s municipal office block. Purpose built it may be but it is over seventy years old and is a little unsuited to modern democratic practice. Local government reorganisation has been a regular feature of each century and with it the reconsideration of the future of this site. Current options range from a partial ground floor conversion for retail and restaurants, to complete sale and reconstruction of a new centre on the edge of town. Inertia is the favourite. (*Tony Jedrej*)

15

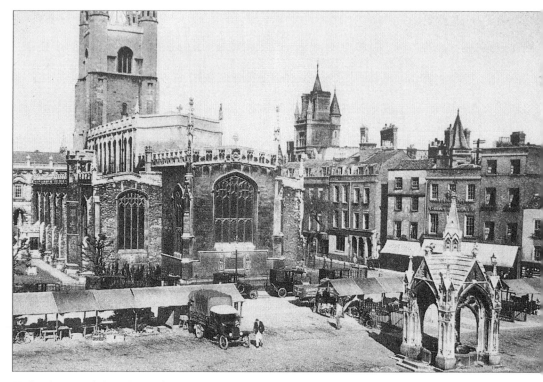

Market Square and Great St Mary's, 1929. Great St Mary's is commonly known as the University Church, even though it isn't. The clearance in 1849 opened up the square in a way that had not been seen since the Middle Ages. Our historic buildings may have been built with some space around them but development increased the density of towns. In addition property owners became more inventive and crowded their buildings into any available space. Not until the release of building land at the edge of the town in the early nineteenth century could some of these ancient views be restored by clearance. (*Cambridgeshire Collection*)

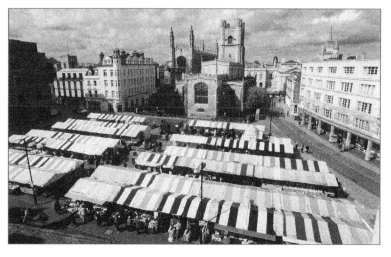

Market Square, 2000. The market may appear traditional but it is now held seven days a week rather than just Wednesdays and Saturdays as it was in previous centuries. The 100 stalls are now concentrated in the square but until the nineteenth century the market spread further with individual trades limited to certain areas. This medieval form of comparison shopping lent names to places like the Green Hill in front of Barclay's Bank, where vegetables had been sold, and the Corn Hill outside what is now Marks & Spencer. (*Tony Jedrej*)

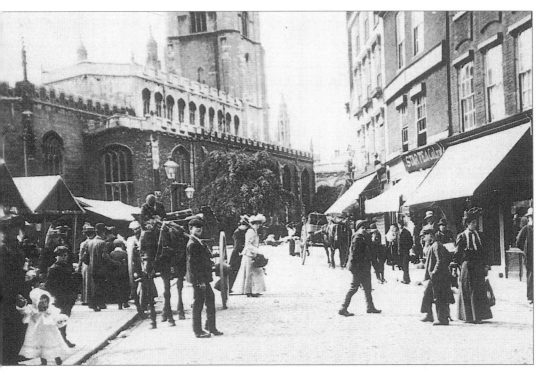

Market day, *c.* 1900. The distinctive shop blinds were made redundant by the protective composition of modern plate glass. Pictures can be dated by ladies' hemlines: they rose throughout the century to 'see level' in the 1960s and then modesty prevailed. (*Cambridgeshire Collection*)

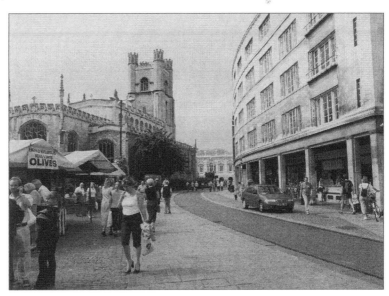

The market, 2000. Great St Mary's tower is one of the few vantage points from which the city can look down upon the university! One commentator described the block to the right as the 'white cliffs of Caius' (the Guildhall was the 'dun cliffs') when the college 'jumped the street' in 1934 and built the student accommodation block with ground-floor shops away from the main college site. There were ten wards or districts of Cambridge at Domesday but only Market Ward has survived, and that in name alone. (*Tony Jedrej*)

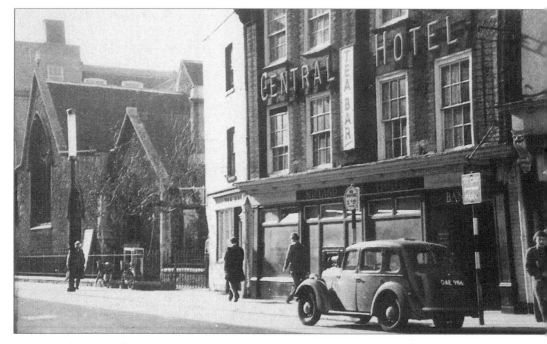

Central Hotel, Market Hill, 1950. This was the historic Three Tuns which played host to the seventeenth-century diarist Samuel Pepys who 'drank pretty hard', but it closed in 1780. By the 1880s it was serving only coffee. It completely disavowed drink at the beginning of the twentieth century and became the Central Temperance Hotel. Underneath the roadway are ancient cellars accessed from St Edward's churchyard. They were used as wine cellars in the 1920s and air-raid shelters during the Second World War. (*Cambridgeshire Collection*)

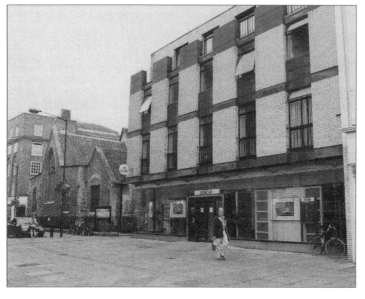

Market Hill and St Edward's Church, 2000. The demolition by King's College of the old Central Hotel in the early 1960s generated some public controversy which was not calmed by the construction of a bank with the Market Hostel student accommodation above it. It may currently be difficult to envisage, but between the sides of this street there was once another block of properties and a thoroughfare called Union Street. When Henry VI went on his shopping spree to buy the site for King's College he also bought the Anglo-Saxon foundation of St Edward and gave it to Trinity Hall. (*Tony Jedrej*)

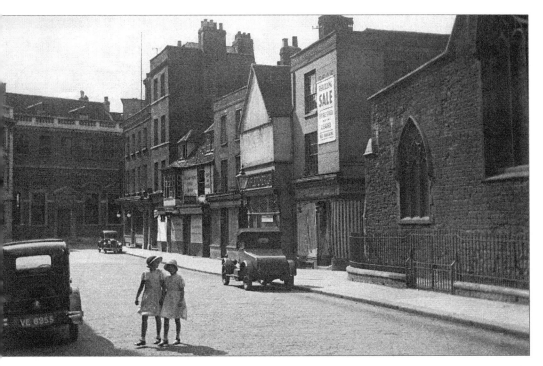

Peas Hill and Barclay's Bank, 1930. John Mortlock opened the first bank in Cambridge in 1780 in his father's drapery shop near the Rose Inn. Within three years he had bought the old Austin friary site and adapted it to be a bank – this later became Barclays Bene't Street branch. Gentlemen were unable to carry money with them to London for fear of robbery, but now Mortlock had radically altered the conduct of eighteenth-century business. He also entered politics and served as mayor thirteen times, always alternating with one of his two sons or business partners. He promoted his own interests and those of his friends; large tracts of charitable and corporation property and funds were squandered. 'Without influence, which you call corruption,' said Mortlock to one of his political opponents, 'men would not be induced to support a government, though they generally approve of its measures.' (*Cambridgeshire Collection*)

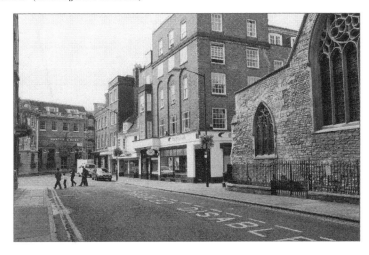

Peas Hill, 2000. Mortlock's bank was considerably altered during the nineteenth century but some original interior features remain. The Cambridge Arts Theatre was founded in 1936 on far higher principles by another Cambridge money man, the great economist, John Maynard Keynes. To make way for the theatre much of the corner site was demolished, although one eighteenth-century building survived. The theatre was rebuilt in 1996 with a major lottery grant but is largely hidden from the street, noticeable only by its modern portico. (*Tony Jedrej*)

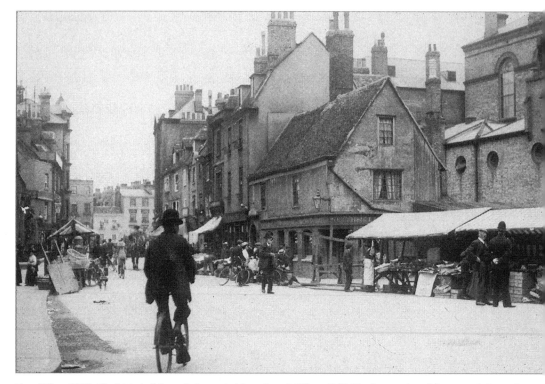

Peas Hill, *c.* 1900. The historic fish market operated here from 1579 until 1949 when modern fishmongers' shops change purchasing habits and ended a centuries-old tradition. The unusual name of the street is a corruption of the Latin for fish *pisces* or *piscaria*. In addition to shops and stalls, delivery rounds were popular. One vendor used to tour the local pubs but afte he had had a beer at every stop it was helpful that the horse knew the way round and home again! (*Cambridgeshire Collection*)

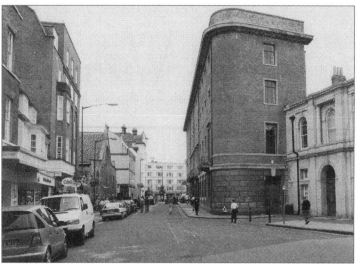

Peas Hill, 2000. The present Guildhall replaced the old Bell Inn and the nearby range of shops and houses in 1935. During demolition, the Bell was found to have been built in about 1450 and constructed with oak ship's timbers including 2-foot wide deck planks. As can be seen from the design, the architect intended to replace the back of the building, including the fine Old Library. The Second World War intervened and the building was saved! (*Tony Jedrej*))

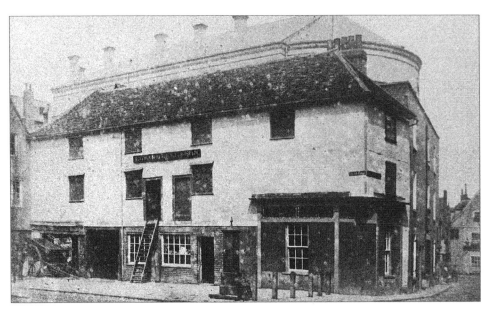

Peas Hill, *c.* 1900. Wheeler Street is reputed to be named after a local basket-maker but was once called Short Butcher Row. Like the colleges, although on a much smaller scale, local government expanded into residential and commercial sites. Behind the old Guildhall stands the large assembly room which has its own organ – this is currently unplayable. Note the water pump, which was installed in 1853 but removed in 1969 after it suffered the attentions of a reversing car after the closure of the fish market. It now stands in the yard of the Folk Museum. (*Cambridgeshire Collection*)

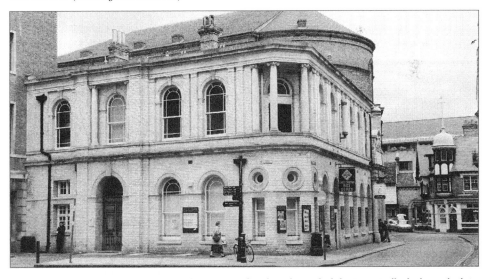

Peas Hill, 2000. The redundant chimneys have been reduced on the roof of the Large Hall which was built in 1865. In 1915 local education offices were built on the site of Edward Bell's corn merchant's shop, which had been burnt down in 1904. The ground floor of the building is currently the Corn Exchange box office. Down the street is the Red Cow pub which survived the Lion Yard redevelopment. (*Tony Jedrej*)

Parson's Court, seen from Livermore Yard across Wheeler Street, *c.* 1870. Cambridge was once littered with small courts and yards, often named after an owner or a particular trade. With each redevelopment a number disappeared but this one has survived. It once housed the stables belonging to John Mortlock. (*Cambridgeshire Collection*)

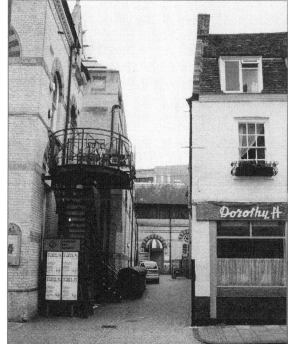

Parson's Court, 2000. The hairdresser's shop on the right is one of the original buildings but all those to the left of it were demolished to build the Corn Exchange in 1874. (*Tony Jedrej*)

King's College
to the River

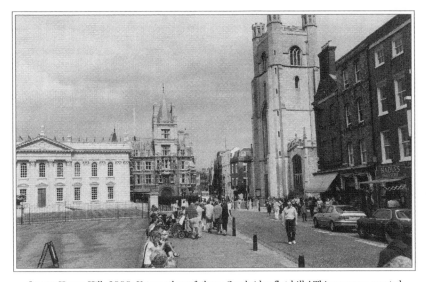

Senate House Hill, 2000. Yet another of those Cambridge flat hills! This one was created when James Gibbs built the Senate House in 1722–30, setting it back from the building line taken from Trinity Street. King's Parade, which leads into the hill, was called Magna Strata in 1250 and then Heighe Warde, Heyestrete and High Street. In the eighteenth century it became Trumpington Street and not until around 1850 did the title King's Parade come into use. (*Tony Jedrej*)

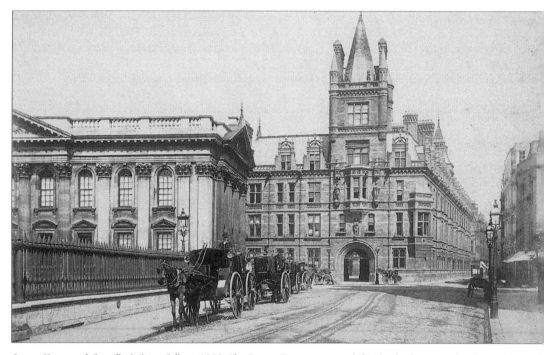

Senate House and Gonville & Caius College, 1880. The Senate House was intended to be the first part of a three-sided court but, like many a Cambridge plan, this was never completed. In 1870 a part of Gonville & Caius called Waterhouse's Tree Court had the affrontery to tower over the university and even compete with Great St Mary's. Note the hansom cab rank and tramlines. The railings, dating from 1730, survived wartime salvaging because they were one of the earliest examples in the country. (*Cambridgeshire Collection*)

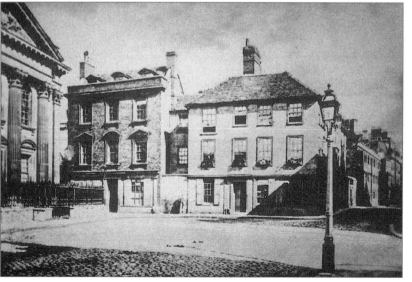

Senate House Hill, 1860. What would your decision have been if you had been asked to decide between saving these attractive old buildings or allowing them to be demolished to make way for a new block? Of course we would not have been asked because planning controls were non-existent until the 1930s. Gonville & Caius acquired this site in 1782 but not until 1854 did the college partially adapt the houses for student rooms. They were demolished in 1870. (*Cambridgeshire Collection*)

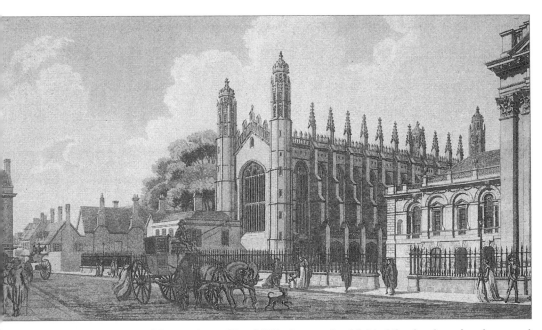

King's College, 1798. The visions of the two Henrys (VI and VIII) who started and finished the chapel may have been grand but incremental encroachment by the town subverted their plan. The houses and shops that crowded out the front of the college were not demolished until 1824, and with them the Provost's (Master's) Lodge. Then a new gatehouse and screen were built by William Wilkins. (*Cambridgeshire Collection*)

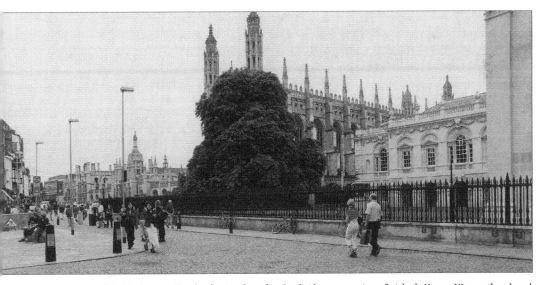

King's College, 'town side', 2000. Even King's, the jewel in the Cambridge crown, is unfinished. Henry VI saw the chapel as part of a four-sided court but for hundreds of years the college grounds remained the largest empty site in the town, disturbed only by bleating sheep. The tree alongside is now an important part of the street scene and accompanies the chapel on the city council's logo, symbolising partnership between town and gown. (*Tony Jedrej*)

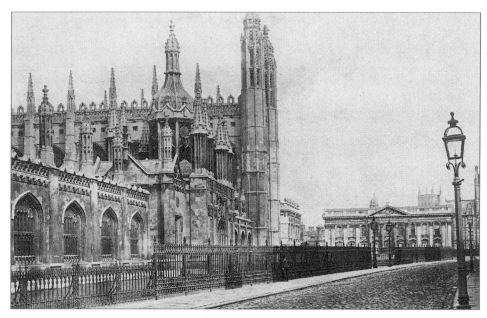

King's College, *c.* 1870. Colleges, generally built around a series of courtyards, have been secure establishments for centuries, keeping the students in at night and the townsfolk out, be they unruly mobs, individual thieves or nocturnal females. A tradition of gating – the closure of the college gates at night – grew up, encouraging a talent for night climbing among more agile undergraduates. The new gatehouse, which cleverly contained some student rooms, was just over fifty years old when this picture was taken. Not all railings were wartime casualties: these were removed in 1927 and replaced with a low wall. (*Cambridgeshire Collection*)

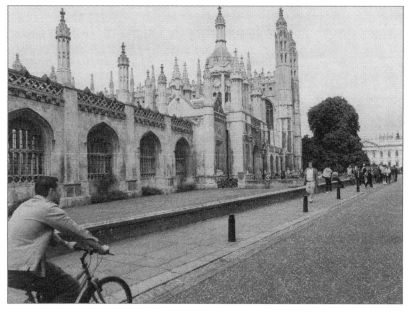

King's Parade, 2000. The parade was closed to through traffic in 1981 and further enhanced by more restrictions and resurfacing in 1999. When Henry VI closed Milne Street to build the chapel, for a time this became the town's main thoroughfare. It is probable that the king was able to make rapid progress on property purchases in the area because river traffic was in decline in the fifteenth century. (*Tony Jedrej*)

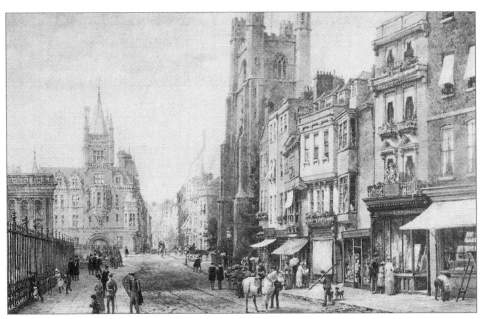

King's Parade, 1887. Painted by Louise Raynor, this is probably the most popular Cambridge view. The original now hangs in the Mayor's Parlour, in the Guildhall, courtesy of the Cambridgeshire Collection. The shops on the parade at this time made their living from the disposable incomes of undergraduates and included tailors, stationers, a tobacconist, a bookseller, a saddler, a photographer, a print-seller and a robemaker. The parade was also a popular haunt of promenaders – people would go out to walk to be seen on a Saturday evening. (*Cambridgeshire Collection*)

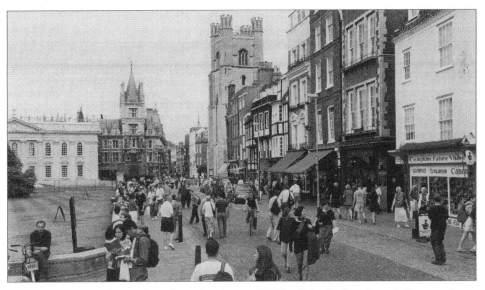

King's Parade, 2000. The shopfronts have altered since 1887 but little else has changed. The street lamps with vertical luminaires are known as Richardson Candles after the designer who first developed them for the Festival of Britain in 1951. They look attractive but, sadly, as lights they are not very effective. (*Tony Jedrej*)

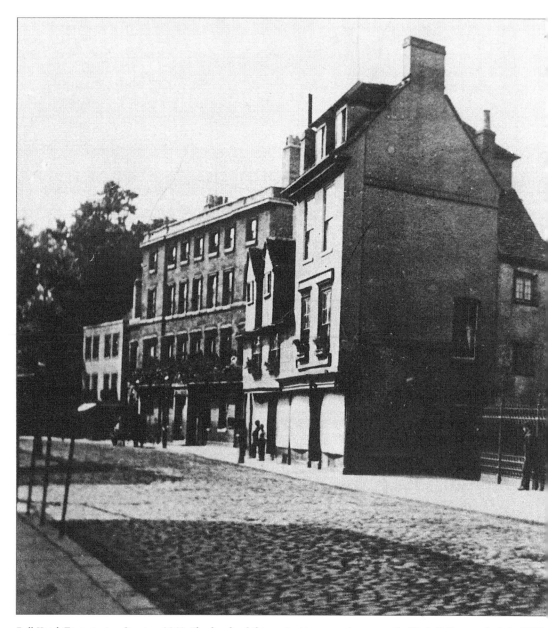

Bull Hotel, Trumpington Street, *c*. 1860. The façade of this ancient inn, once known as the Black Bull, was rebuilt in 1828. The building next door, the White Horse Inn or 'Little Germany', was an important meeting place for religious thinkers during the Reformation in the sixteenth century and played an historic part in the political and religious development of England. The owner, Cory, presented a settle to the Cambridge Antiquarian Society. It is now in the Fitzwilliam Museum and was believed to have been the seat of Miles Coverdale, a leading sixteenth-century Bible translator. Cory refused to sell his shop to King's in 1824 and it survived for nearly fifty years until his death in 1869 when the college was finally able to complete the purchase and continue redevelopment in the area. (*Cambridgeshire Collection*)

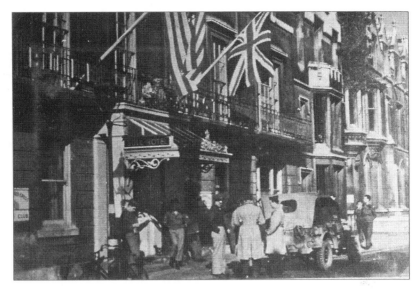

Bull Hotel, 1944. In 1843 Mr Crisford advertised his hotel to the 'Nobility, Gentry and Public', promising warm, cold and shower-baths adjoining the bed chambers', and it was later claimed that the Bull was much frequented by visiting royalty, Australians and Americans. The latter must have liked it because they came back during the Second World War and took it over as a headquarters. At the end of the war the hotel housed troops studying on short courses at the university and was known as Bull College. It never reopened as a hotel. (*Cambridgeshire Collection*)

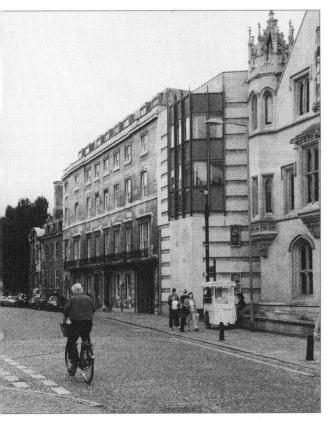

Bull Hotel, 2000. In 1626 Dr Gostlin, Master of Gonville & Caius, bequeathed the Bull to the impoverished St Catherine's College, rather than to his own college. Thereafter the fellows of Caius were said to have drunk a regular toast to the unhappy memory of Dr Gostlin who was such a goose as to leave the Bull to Cat's. St Catherine's reclaimed the Bull for student rooms when the Americans left after the Second World War and, in a partnership with King's, in the 1960s it demolished all but the façade after removing the canopy. (*Tony Jedrej*)

29

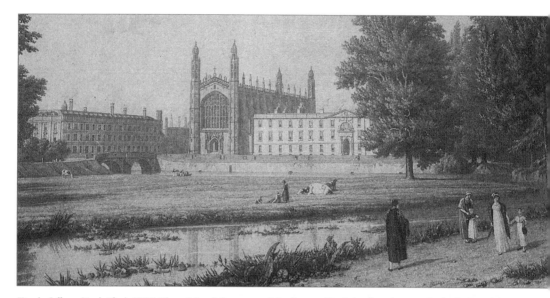

King's College, 'Backsides', 1819. The origin of the name of the famous 'Backs' is that they are the backsides of the colleges. A casual observer may contrast this with the modern picture below and remark that at least little has changed here. However, the bridge was removed in 1819 and its replacement was erected some distance away to present the visitor with an oblique view of the chapel on entering the college grounds. The full picturesque vista is revealed after crossing the river. (*Cambridgeshire Collection*)

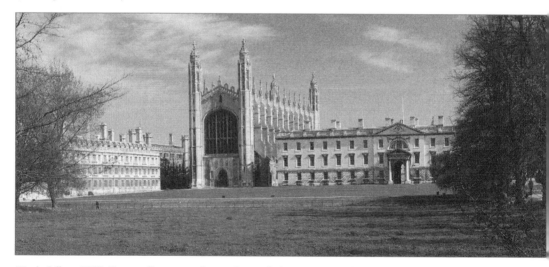

King's College, 2000. Two small tree-topped mounds are all that remains of the former causeway which led to the bridge. The fields are used for grazing which gives a rural foreground to the college's splendour. The Backs are now historic gardens, of which the river is an integral part. The establishment of King's in the fifteenth century resulted in the closure of the main quays in the port area. Buildings and warehouses that lined this part of the river were cleared. Other colleges continued the process of squeezing out the river trade by buying up riverside property. River freight traffic was forced to concentrate at Quayside to the north and the Mill Pond to the south. As all the colleges united to resist the establishment of a tow-path, a gravel bed was laid for horses to wade up and down the river. (*Tony Jedrej*)

Garrett Hostel Bridge, c. 1870. The name comes from a hostel with a garret or watchtower which was later incorporated into Trinity College to become Bishop's Hostel. Most riparian colleges built their own private bridges to provide access to their gardens and bowling greens. The general population was forced to use the Great Bridge next to Quayside or Small Bridges at the Mill Pool. However, in compensation for the loss of crossings, Henry VI gave the town this bridge site and its access lane in the fifteenth century. It was rebuilt in 1626 and again in 1789 and became Cambridge's first 'Mathematical Bridge'. This much-loved version of the bridge was erected in 1835. Because of a costly fracture, which made repairs seem uneconomic, it was replaced in 1960 with a steep-pitched arch. This gives cyclists a difficult approach and works as a form of traffic calming. (*Cambridgeshire Collection*)

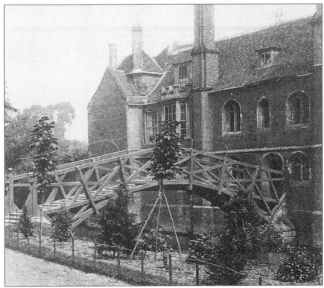

The Mathematical Bridge, Queen's College, c. 1870. Queen's College bridge, also commonly known as the 'Mathematical', was said to have been built without nails in 1749, although the timbers were probably pegged together. It was rebuilt in 1867 and 1902. The most unusual bridge story comes from Clare Bridge, which apparently has fourteen large stone balls on its parapet. Closer examination reveals that one of them has had a segment removed. The reason for its absence has been the subject of many a wager. Its loss is reputed to have been the result of an undergraduate prank or the architect's revenge for the short settlement of his fee. (*Cambridgeshire Collection*)

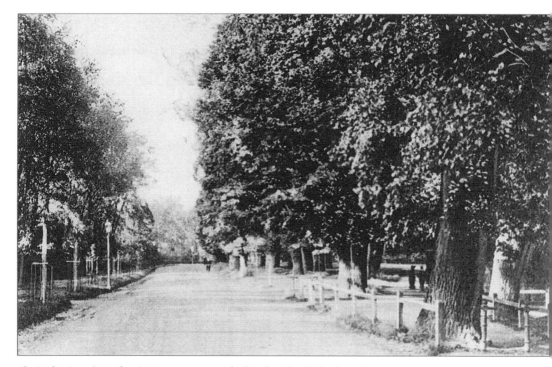

The Backs, Queen's Road, *c.* 1900. Not a car in sight, but then they had only just been invented. Another recent introduction was a sewerage system which resulted in the cleaning of the river. When Queen Victoria crossed the river at Trinity in 1847 she had enquired about the nature of the pieces of paper floating in the water and was adeptly informed by the master that they were notices prohibiting bathing! In the Middle Ages sanitation problems were no different – one of the streets leading to the river was Pisspot Lane. With the cessation of river traffic and the improvement in hygiene, the river became ever more popular with pleasure seekers. (*Cambridgeshire Collection*)

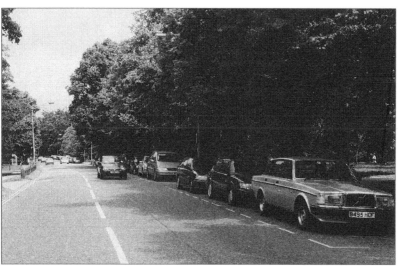

Queen's Road, 2000. Cars abound but the trees remain. In fact many died in the Dutch elm disease epidemic in the 1970s. Various plans have been mooted to reduce traffic in this area, including a tunnel under the full length of the Backs. (*Tony Jedrej*)

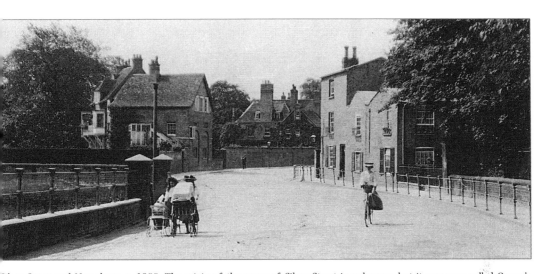

Silver Street and Newnham, *c.* 1900. The origin of the name of Silver Street is unknown, but it was once called Queen's College Lane and the section across the river was called Newnham, along with the rest of the small settlement around it. On the immediate left is the Hermitage and the old Granary built for the Beales family, corn and coal merchants. The house name commemorates a hermit whose function was to maintain the medieval bridges. His duties ceased in 1579. The houses to the right were occupied by senior servants from Queen's College. In 1823 the Beales family, living as they did on the west bank, successfully challenged the right of the corporation to charge *2d* per wagon or carriage to bring them into the town. (*Cambridgeshire Collection*)

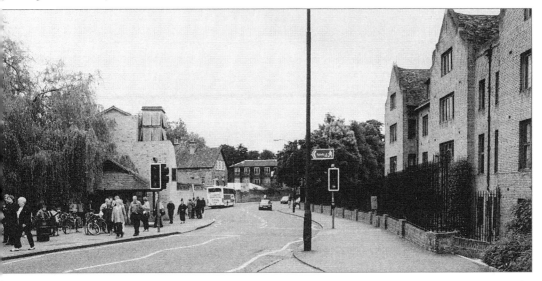

Silver Street, 2000. Both the Hermitage and the Granary are now part of Darwin College, which was founded in 1965. The building in the left foreground is the new college library built in 1994 with its unusual ventilation unit. The Fisher Building on the right was built in 1936 by Queen's College and one of the old small bridges was made redundant by filling in the channel which served the Queen's Ditch. A pipe runs from the Mill Pond to the ditch so that fresh water can flow into the ancient watercourse. The structure in the left foreground is the entrance to a set of underground toilets. This area is also a popular tourist coach terminus. (*Tony Jedrej*)

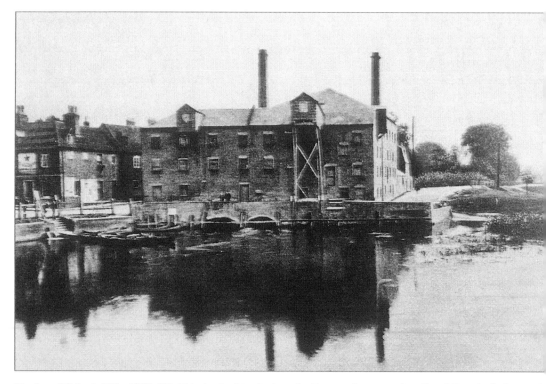

King's and Bishop's Mills, 1900. This historic site dates back to the Norman Conquest when Sheriff Picot built the King's Mill alongside that of the Bishop of Ely. Both jealously guarded their rights to water and competed with Newnham Mill a little up stream. When King's Mill drew water, a horn signal was given so that Newnham Mill would stop. Over the years both the King's and Bishop's came into common ownership and under one roof, with a steam engine augmenting water power. With the arrival of the railway in 1845 Foster Brothers, who by then owned all three river mills, built a new steam flour mill at the station and their river operation went into a slow decline. It was demolished in 1927. (*Cambridgeshire Collection*)

Opposite, top: The Mill Pond, 1929. The site of the King's and Bishop's Mill had been almost cleared leaving only the mill races. On the corner stood the Mill pub. Alongside were housing and laundries in Granta Terrace and Place. At one time these buildings were the stables of Sindalls, the builders who were later to construct the University Centre. Punts now ply for hire where it was said you once could walk from one side to the other on barges. (*Cambridgeshire Collection*)

Opposite, bottom: Mill Pond, 2000. The University Centre, nicknamed the Gradpad, has dominated the view since it was built in 1964 but the Mill pub has survived all the changes. In the background is the modern Garden House Hotel, which began modestly as the Belle Vue. The grassland beside the former mill is Laundress Green, named for its former use as a drying area for generations of academics' washing. (*Tony Jedrej*)

34

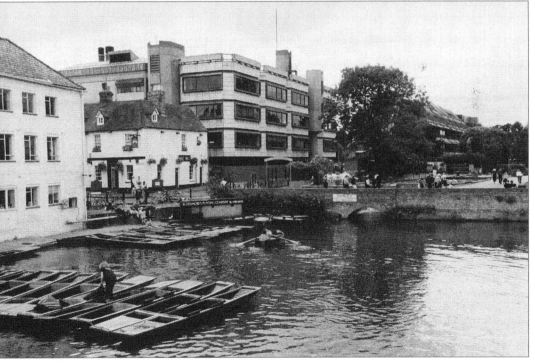

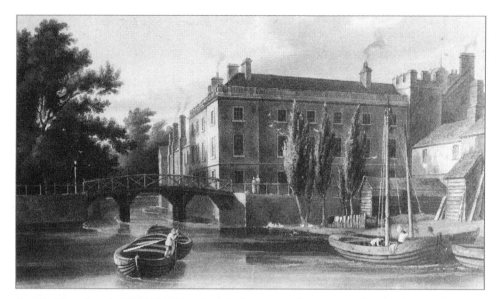

Queen's College from the Mill, 1814. Silver Street Bridge was once known as Small Bridges because there were two crossing points, one of which is now hidden, in contrast to the Great Bridge at Magdalene. In this period river freight had its heyday. Decline came with the arrival of the railway but it was not a foregone conclusion. One of the many railway proposals included a station in Silver Street and another at Newnham, although strangely none for Quayside. Boating on the Cam would not have been the same if the plans had gone ahead. (*Cambridgeshire Collection*)

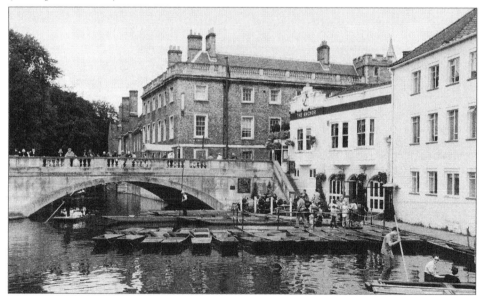

Queen's College from the Mill, 2000. An Anchor boatyard manager is said to have introduced punts to the Cam after seeing them at Henley, thereby creating one of the most enduring images of academic Cambridge. Now you can walk across the river on punts – well, almost. (*Tony Jedrej*)

Petty Cury through the Trumpington Gate to Spittle End

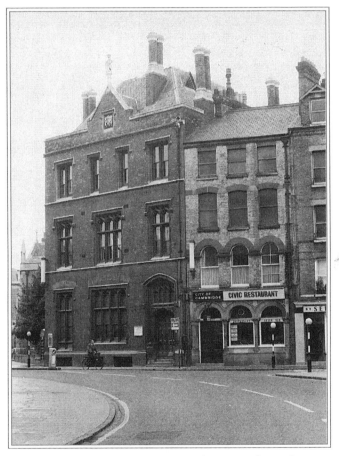

Civic Restaurant, Petty Cury, *c.* 1969. Popular municipal eating houses were created in wartime but continued until 1972. The fine arcade was originally created for the Midland Bank in the 1920s. When Petty Cury was demolished to create the Lion Yard, this shopfront was the very last structure to be removed. Separates, next door, was the first Cambridge shop to sell sweaters and skirts rather than dresses. The proprietor was noted with affection by residents for her limpet-like sales technique – once in, there was no escape without a purchase. (*Norman Mason-Smith*)

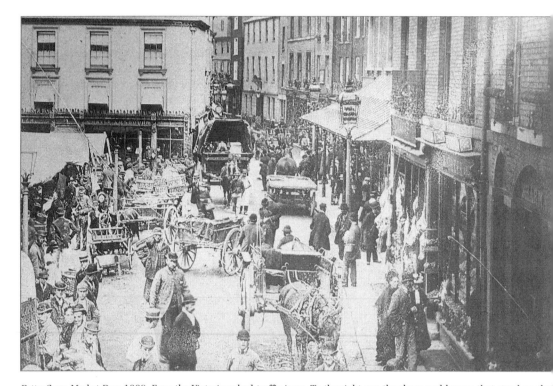

Petty Cury, Market Day, 1880. Even the Victorians had traffic jams. To the right ran the shops and houses that stood on the corner of Butter Row, followed by the canopied front of the old Shire Hall. In the distance on the right of the Cury can be seen the front of the Lion Hotel, which gave the Lion Yard area its name. Josiah Chater was a local mid-Victorian diarist of note and based his draper's shop in the building which many confuse with Joshua Taylor's in Market Street because of their similar appearance. He later became secretary to the Cambridge Street Tramways Company and his writings are a unique insight into life in a Victorian town. (*Cambridgeshire Collection*)

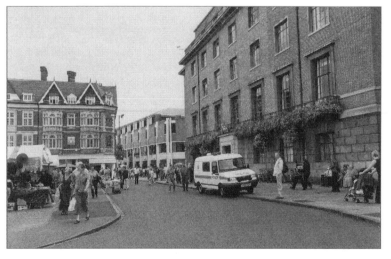

Petty Cury from the Market Square, looking down the Cury with the Lion Yard Shopping Centre to the right, 2000. Petty Cury was the premier shopping area in the town during the eighteenth century and in 1788 was the first to be paved and later lit. The view has changed beyond recognition over the past 100 years as the demands of modern retailing have created premises suited to the business of the day. (*Tony Jedrej*)

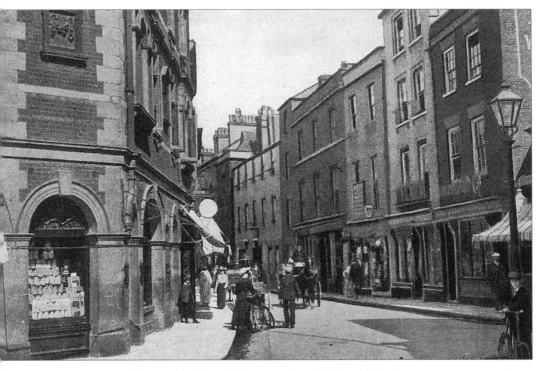

Petty Cury, *c*. 1900. The large building on the left was built in 1889 for Hallack & Bond, 'family grocers, provisions merchants, tea blenders and coffee grinders'. When Chater's shop was demolished, old stone fireplaces were revealed which dated the building to 1538 and identified it as belonging to a John Vesey. One of the fireplaces is now in the Tourist Information Centre. The shops in view on the south side of Petty Cury included a wine and spirit merchants, a hatter, fancy repository and what became Heffers, the well-known booksellers, next door to the Lion. (*Cambridgeshire Collection*)

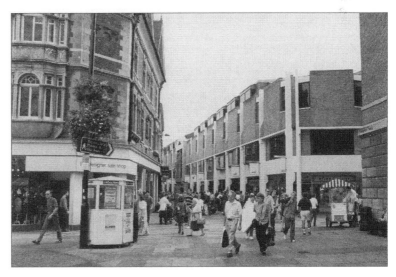

Petty Cury, 2000. Medieval trades were organised on a street basis and their names were often blunt, to the point and descriptive of what took place. Even the academics were not immune from unsophistication: an entry in St Catherine's College archives records a payment to 'Batty for mending the bog-house'! Petty Cury was the street of kitchens or inns. Originally it was called Parva Cokeria which was later corrupted to le Pety Cury, from Old French, *curie*, meaning kitchen. The Lion Hotel was the last inn to close. (*Tony Jedrej*)

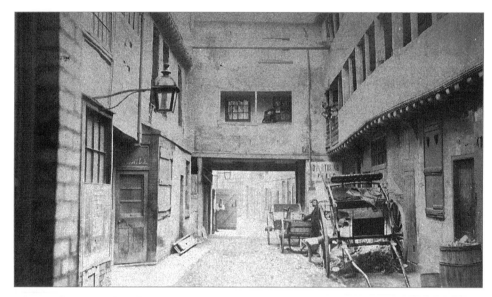

Falcon Yard, *c.* 1880. The galleries date back to the time of Elizabeth I; it was said she stayed the night in the Falcon Inn. However, by the nineteenth century this area of the town was not fit for the labouring poor, let alone royalty. There were over twenty-five separate units of accommodation crammed into the yard on first- and second-floor galleries with several families sharing each privy. (*Cambridgeshire Collection*)

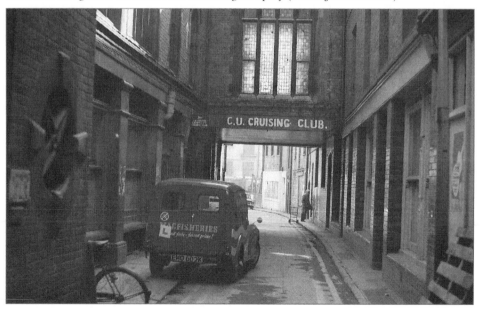

Falcon Yard, *c.* 1965. Yet another historic street was extinguished with the construction of the Lion Yard Shopping Centre in the '70s. Victorian rebuilding had already changed the original yard beyond recognition. The bridge over the street with the stained-glass windows was the link from the Lion Hotel to its nineteenth-century annexe. (*Norman Mason-Smith*)

Alexandra Street, 1969. It was named after the popular Princess of Denmark who married the Prince of Wales in 1863. This street was itself a relatively modern creation, made out of the Red Hart Yard and Antelope Inn. The frontage to Petty Cury was rebuilt after the demolition by Robert Sayle of the Wrestlers, an ancient, pargetted, timber-framed inn. There were shops at ground level and the floor above housed the Livingstone Commercial Temperance Hotel. In the street itself was Henekey's Bar, also known as the 'Bed-Makers Arms', with its wood-panelled interior. (*Norman Mason-Smith*)

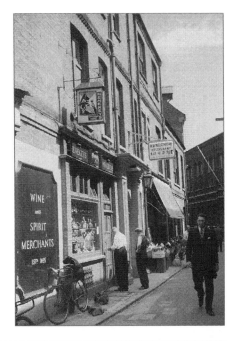

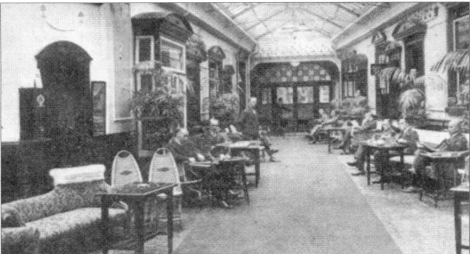

The Lion Hotel, *c.* 1930. Turning coaches around became increasingly difficult in the cramped, narrow streets, so many Cambridge inn yards were entered from the front and exited at the back. When the inns ceased trading their yards were often turned into streets, for example the Rose's became Rose Crescent and the Black Bear's became Market Passage. The Lion, however, erected a glazed roof in 1895 and used its yard as a lounge. At the beginning of the twentieth century Alice Ann Moyes, a widow, and her family ran two other hotels in the town and made the Lion the town's leading family and commercial establishment. For many years, even after demolition, a flower seller sat in the doorway crying out 'Violets, lovely Violets'; this was a good cover for his secret trade in betting. (*Cambridgeshire Collection*)

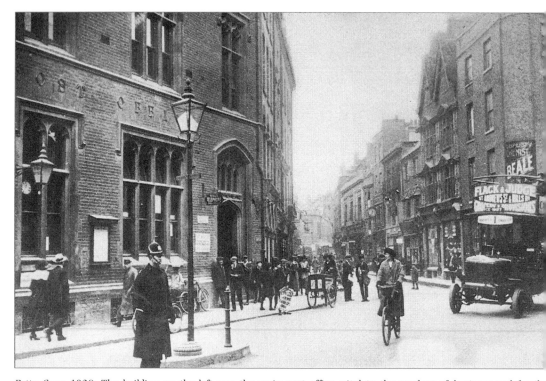

Petty Cury, 1920. The building on the left was the main post office, vital to the conduct of business and family communications before the widespread introduction of the telephone. There were nine collections per day in 1895, with two on Sundays, and six deliveries. The bus looks as if it could hardly make another journey! (*Cambridgeshire Collection*)

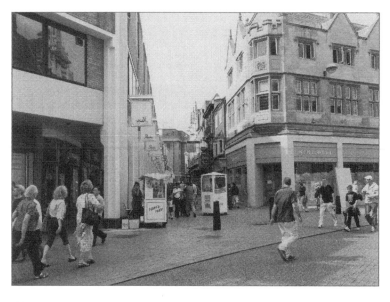

Petty Cury, 2000. Almost everything has changed. The buildings on the left have been swept away to be replaced by Lion Yard. On the right the corner with Sidney Street has been demolished and replaced by an extension of the Boots building. (*Tony Jedrej*)

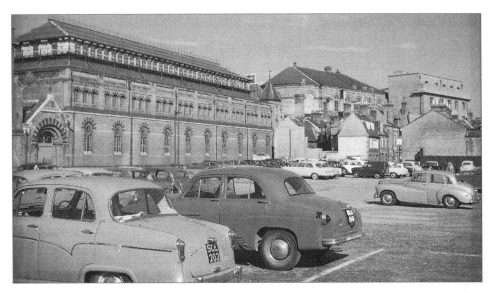

Lion Yard, *c.* 1965. Much of the area in the picture above was cleared for car parking for Lion Yard. In 1963 the hotel closed all but its bars, which went five years later. The victory of the car was total. The side of the Corn Exchange and the unfinished back of the Guildhall can clearly be seen. (*Norman Mason-Smith*)

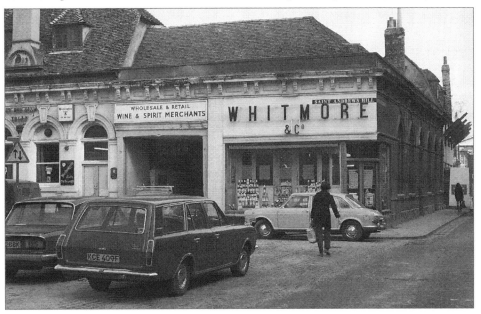

St Andrew's Hill, *c.* 1965. More flat Cambridge hills. Sadly, the name did not survive the redevelopment. This area was previously known as Fare Yard, Hog Hill and the Cattle Market. The latter moved to Honey Hill in the Castle area in the 1840s. With the arrival of the railway it had to be moved again. Whitmore's was lost to make way for the rear part of the new Norwich Union Building. The Bun Shop (to the left) was a favourite haunt of construction workers – it was naturally one of the last buildings to be demolished. (*Norman Mason-Smith*)

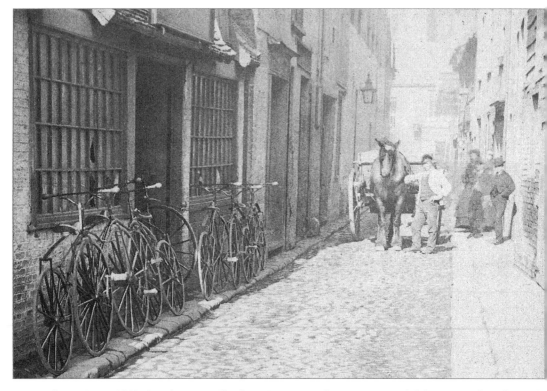

Corn Exchange Street, 1865. Once known as Slaughter House Lane, this narrow street led from Hog Hill or the Cattle Market, to Butcher Row and then on to Petty Cury. This was the medieval food route, which saw animals bought, slaughtered, butchered and then cooked, all in connecting streets. Hides then went on to Shoemaker Row, the modern Market Street. (*Cambridgeshire Collection*)

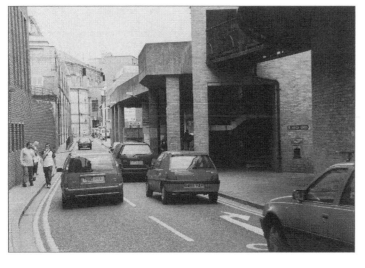

Corn Exchange Street, 2000. Despite complete reconstruction, since the mid-Victorian period this street has remained narrow. Failed plans to build a bridge to connect the Lion Yard car park and the university's new museums site made the deck above the entrance redundant and turned it into the most useless space in Cambridge. It will soon be demolished as part of the Grand Arcade car park reconstruction. If the internal-combustion engine had never been invented would we be debating at length about horse traffic and building multi-storey stables? On the left is the Corn Exchange which ceased trading in 1965 and was converted by the city council into a major performance venue twenty years later. (*Tony Jedrej*)

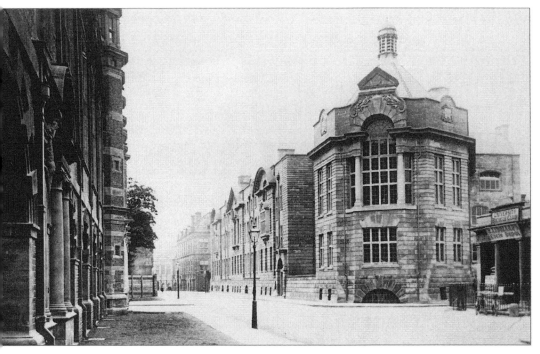

Downing Street and Pembroke Street, c. 1900. Given that this is one of the university's most densely packed sites, it is somewhat surprising to find that it was once the garden of an Austin friary. It became the university's Botanic Garden from 1760 until the latter moved to part of its present site on Trumpington Road in 1852. (*Cambridgeshire Collection*)

Downing and Pembroke Streets, 2000. Once called Dow Divers Lane, Downing and Pembroke Streets were not formally connected until the nineteenth century. The track ran alongside the medieval King's Ditch, a minor defensive earthwork that ran from the Mill Pond and skirted the east of the town via the Barnwell Gate next to Christ's College to rejoin the river. The ditch was a source of continual complaint because of the rubbish deposits and privies that stood on its banks. From time to time it had to be flushed out or scoured. (*Tony Jedrej*)

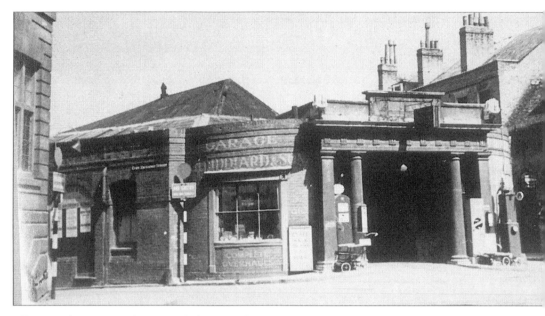

Old Corn Exchange, 1939. This purpose-built Corn Exchange was erected in 1842. Within a few years it could not cope with the volume of trade and a new exchange was constructed in Wheeler Street in about 1874. Cambridge, like other market towns, was an important trading centre in the nineteenth century but with improvements in communications, market trading went into decline. Cambridge today would appear to have little to do with modern farming. (*Cambridge Collection*)

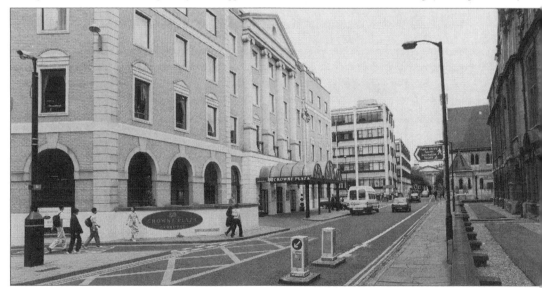

Crowne Plaza Hotel, 2000. The old Corn Exchange was an early casualty of the creation of car parking at the back of Lion Yard. When a hotel was constructed on the site, the Holiday Inn, archaeologists excavated the King's or Black Ditch. Its reputation as a foul open sewer was reborn as the diggers found that even after centuries of not being used it still exuded an indescribable smell. (*Tony Jedrej*)

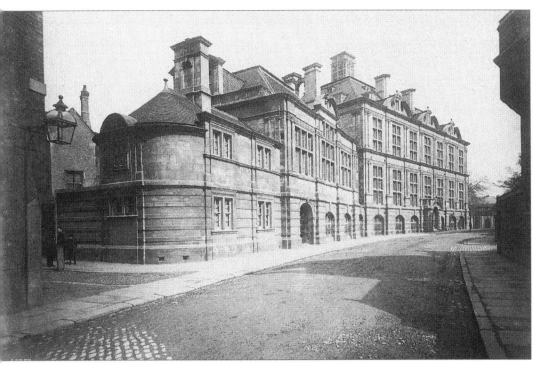

Pembroke Street, *c.* 1880. The transfer of the Botanical Garden was one of the first major relocations to what was then the edge of town in order to free land in the centre for building. These were the first buildings which spread across the site. Another was constructed across the road to the north of Pembroke College. They were the product of mid-nineteenth century reforms in university science education. The result was a dense complex of museums and laboratories which continued to grow throughout the following century. (*Cambridgeshire Collection*)

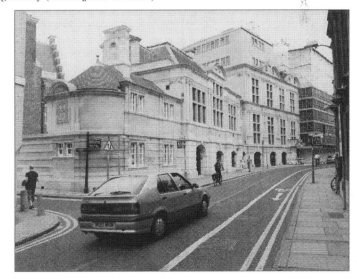

Pembroke Street, 2000. Little appears to have changed although a closer examination of the roof line is revealing. Note the scaffolding in the distance. The university has at last begun cleaning the street frontage in stages, restoring individual details and generally brightening the area. (*Tony Jedrej*)

47

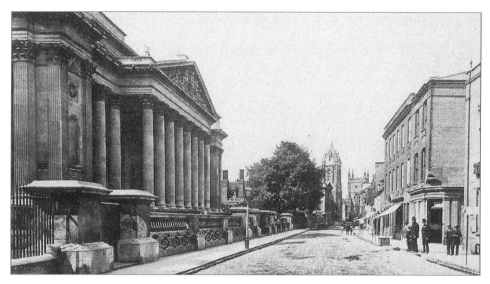

Fitzwilliam Museum, *c.* 1880. The museum was the bequest of Richard, 7th Viscount Fitzwilliam, to the university in 1816 but work did not begin until 1837 and was not completed for nearly forty years. The modern planning process is often criticised for a lack of pace but it is put into perspective when compared to the fifty-nine years taken to complete the museum or the seventy-five for King's Chapel in an age when life expectancy was half what it is today. Like all stone creatures the 'Fitz Lions' are said to come down to drink from the wartime fire reservoirs at the stroke of twelve. (*Cambridgeshire Collection*)

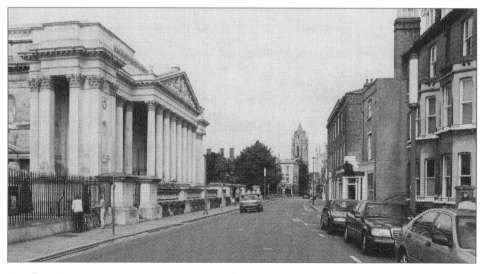

Fitzwilliam Museum, Trumpington Street, 2000. Little has changed. In the distance is the solid tower of the Emmanuel Congregational Church and the University Press Pitt Building which was built with money left over from funds collected for a statue of Prime Minister William Pitt. On the far right, the Little Rose is one of the few inns that have survived from the Elizabethan age. Hobson's runnels are sited on both sides of the street and were built in about 1794; prior to their construction the stream, or New Cambridge River, flowed down the middle of the street. (*Tony Jedrej*)

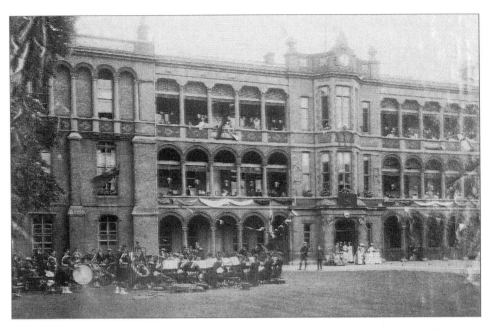

Addenbrooke's Hospital, 1911. It was founded by John Addenbrooke and building started in 1740, but it was subsequently extensively altered. The hospital began to decant to its present edge-of-town site in 1960 and old Addenbrooke's closed in 1984. The open colonnades, as seen in this picture of coronation celebrations, were enclosed in 1938. (*Cambridgeshire Collection*)

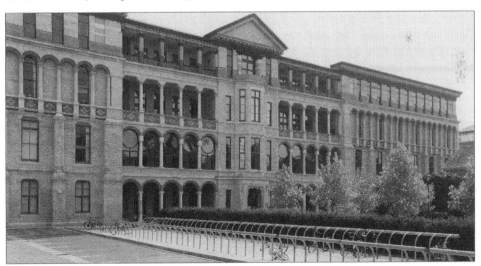

Judge Institute, 2000. In 1995 the old Addenbrooke's building became the Judge Institute of Management Studies in one of the finest examples of a modern conversion of an historic building. The architect kept the façade but rebuilt the rear in a distinctive and colourful style that will make this building a tourist attraction for years to come. Until recently the top-floor wards remained unused and in their original condition. The outpatients department became Browne's restaurant. (*Tony Jedrej*)

49

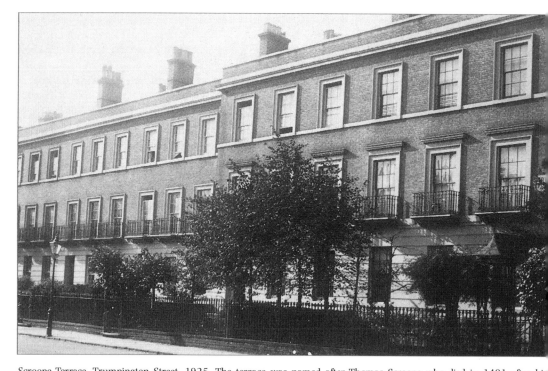

Scroope Terrace, Trumpington Street, 1925. The terrace was named after Thomas Scroope who died in 1491 after his widow, Lady Scroope, the last of the Gonvilles, left the Manor of Newnham and 99 acres to Gonville Hall. Nos 1–7 were built in 1839, followed by nos 8–12 in 1864. Scroope House was at the rear of the terrace until it was occupied and then replaced by the university's engineering department, which moved from the Downing site in 1919. (*Cambridgeshire Collection*)

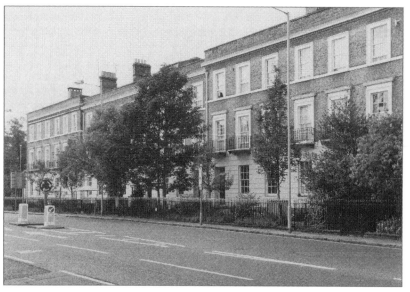

Royal Cambridge Hotel, 2000. Converted from nos 8–12, its reception was at the back. Nos 1–7 now contain the university Department of Architecture. The hotel stands on the corner of the Fen Causeway, another river crossing, which wasn't constructed until 1926 when the corporation wanted to provide work for the unemployed. (*Tony Jedrej*)

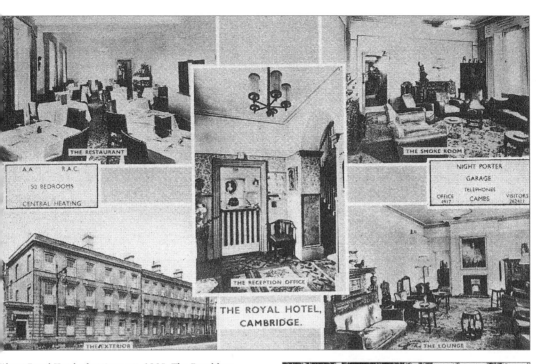

Above: Royal Hotel advertisement, 1930. The Royal has survived not only competition for land use, but also the transformation of English society. This transformation changed the expectations of hotel clientele and their transport needs and saw the demise of some of the Royal's contemporaries, most notably the Bull, the Blue Boar, the Lion, the Livingstone and the Central. (*Cambridgeshire Collection*)

Hobson's Conduit, 2000. It now stands at the junction of Lensfield and Trumpington roads, where the stream bringing fresh water from Nine Wells branches off along Trumpington Street in an open conduit on both sides of the road, and is piped to St Andrew's Street. The pineapple crowns the monument as a symbol of prosperity. When the conduit was moved in 1856, a disgruntled poet penned the following lines on its behalf: 'Yet wait awhile, the glory of my fame/ Will shine upon the Market Hill again,/ With one accord you will then think of me,/ And hail the joys of Hobson's charity.' Recent aborted plans to resurface the market actively considered returning the conduit to its original home rather than installing a modern sculpture. (*Tony Jedrej*)

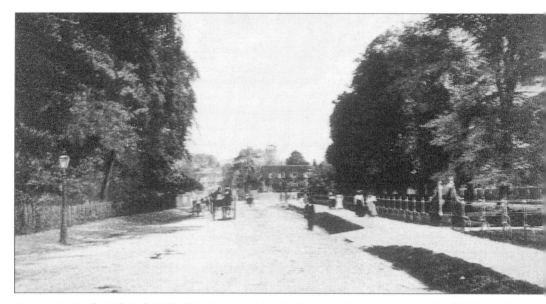

Trumpington Road, Spittle End, 1905. This picture was taken looking towards the junction with Lensfield Road, which was for many years the edge of built-up Cambridge. The group of houses in view and those that front Trumpington Street were commonly called Spittle or Spital End. They were a medieval foundation of the hospital of St Anthony and Elegius which still had a chapel in the mid-sixteenth century. The last building was demolished in 1852 and replaced with almshouses in Panton Street. (*Cambridgeshire Collection*)

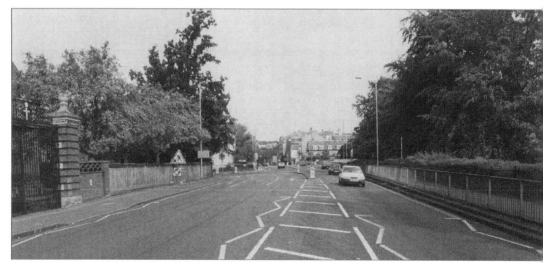

Trumpington Road, 2000. A comparison of this and the previous photograph shows the difference that kerbs and made-up roads have on the atmosphere of the street scene. In what may have become a very stark, harsh environment owing to modern road engineering we must be grateful for the foresight of the tree planters, not only here but throughout the city. On the left is the independent Leys School which was established in 1874 by Wesleyan Methodists to provide high-class education for the sons of ministers and laymen of all denominations. One of the first buildings here was a house constructed by local department store owner Robert Sayle. (*Tony Jedrej*)

St Andrew's Street
to the Station

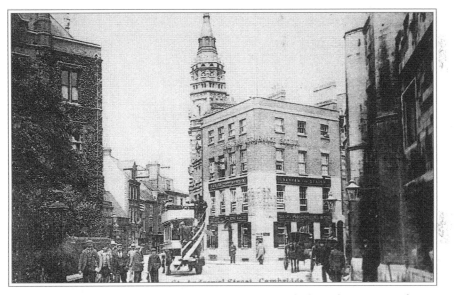

St Andrew's Street, *c.* 1910. This is the Barnwell Gate to Cambridge at the junctions with Sidney Street, to the left by the post office, and Hobson Street, to the right by Christ's College (formerly God's House). St Andrew's Street has previously been called Hadstock Way, Black Friars Lane and Preacher's Lane. Hobson Street is on the line of the King's Ditch and led to Wall's End, now King Street. The tower and steeple are the main features of what is now a branch of Lloyds TSB, and in rivalling the monuments of the established church reflected the dissenting origins of the powerful Foster family who built them. Erected in 1891, the building has a remarkable tiled banking hall and the lintel over the front door still carries the family name. In an age when there had been some instability in banking the aim was to create an image of durability and security.
(Cambridgeshire Collection)

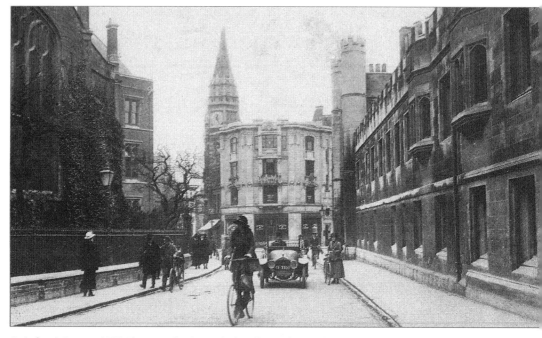

St Andrew's Street. *c.* 1920. The corner has been rebuilt with new shops and offices above. To the left is the church of St Andrew the Great, the origins of which may go back to Domesday. Rebuilt in 1842, it contains a memorial to Captain Cook – his widow and two of his children are buried here. For many years the church at the entrance to the Lion Yard stood redundant. After long deliberations about its future, including proposals to convert it into shops and a tourist information centre, it was re-established in the '90s as a church when the growing congregation moved from the Round Church. A new planning application was required for a church which had been on the site for nearly 1,000 years! (*Cambridgeshire Collection*)

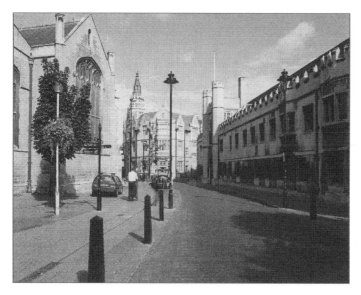

St Andrew's Street, 2000. Lloyds Bank finally acquired the corner site from the City Council in 1935 and rebuilt it in a similar style to the original. When laden shoppers toil past this site or night revellers await their taxis, few give much thought to the origins of the college opposite. It was founded as God's House in 1442 when Henry VI persuaded the Master to give up the college's original buildings which stood on the site of King's Chapel. The king promised a replacement, but progress was slow until Lady Margaret Beaufort, mother of Henry VII, refounded the college in 1505. The huge coat of arms over the gateway is similar to the one at her later foundation, St John's College. Modern Cambridge's urban landscape has a direct link to the royal houses and religious struggles of England. (*Tony Jedrej*)

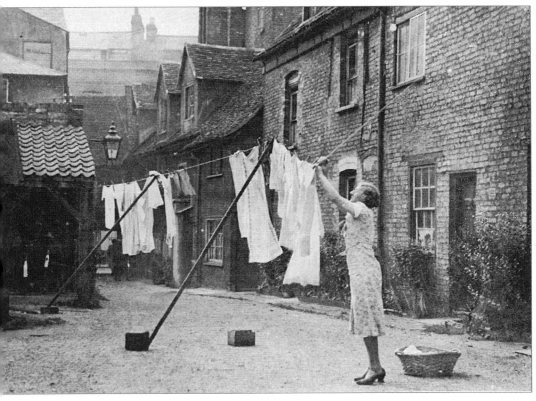

Bradwell's Yard, 1934. Builder Thomas Bradwell could have had no idea that his name would be bequeathed to such a major retail site. Nothing now remains of the original yard with its small-scale housing nor of the shops that fronted St Andrew's Street and Christ's Lane. Stanley Woolston's antiques shop had a frequent important visitor but it is said Woolston bemoaned the royal practice of not carrying any money! (*Cambridgeshire Collection*)

Bradwell's Court, 2000. The freehold is owned by Jesus and Christ's College who jointly developed this property in 1962 as Cambridge's first shopping precinct. It lies on the major route from the historic centre to the bus station and the Grafton Centre. At the request of the county council the new building was set back from the original building line to create a bus bay, but this is now a one-way street going the wrong way, rendering the bay obsolete! The street trees have begun to screen and soften the view of this unremarkable edifice. To the left is the stopped-up remnant of Christ's Lane which still sports the street sign. (*Tony Jedrej*)

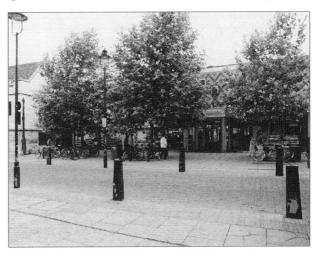

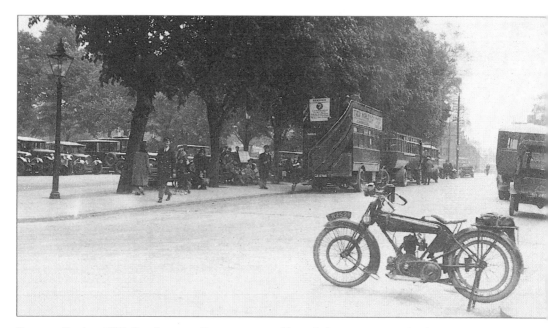

Drummer Street, *c. 1925*. Once known as Drusemere, or muddy pool, this street contained a dipping pool from which the public could draw water fed from Hobson's Conduit. The bus and car park was opened in 1925; though the encroachment on to the precious open space of Christ's Pieces was highly controversial, the pressure for parking meant that New Square soon followed. Christ's Pieces itself was bought by the Town Council, not from Christ's but from Jesus College in 1884 for £500, and a similar amount was spent on landscaping. (*Cambridgeshire Collection*)

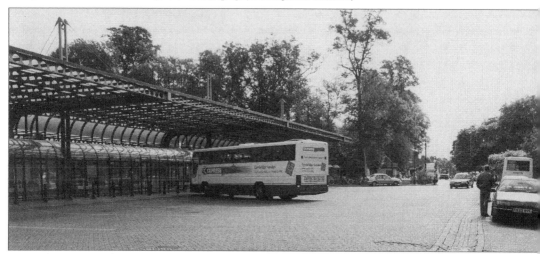

Drummer Street, 2000. Even up to the late 1930s the trade directory entries regarding the bus station had a quaint ring: 'a parking place and starting point for motor buses etc'. The central island was later converted to waiting areas and booking offices for Eastern Counties and Premier Travel but this was all swept away with the construction of the new canopy in the early 1990s. The debate regarding buses goes on in proposals to move the long-distance coaches to what is now a more fashionably termed 'transport interchange'. (*Tony Jedrej*)

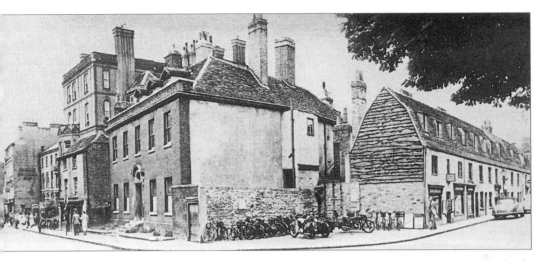

St Andrew's Street, 1957. This picture was taken at the junction with Emmanuel Street, once known in medieval style as Praise-Be-To-God Street. The tall building was built by a local solicitor and alderman; it was so spacious it even had its own ballroom. It was nicknamed Rance's Folly and it ruined him. The other buildings in the vicinity were eighteenth- and nineteenth-century frontages with various rooflines. The Emmanuel frontage was lined with eighteenth-century brick cottages which had tiled mansard roofs. The corner shop had already been demolished, but on this occasion to provide spaces for cycles not cars. In the early twentieth century Emmanuel College proposed closing the street so its students could move safely between the new North Court and the main college, but a subway was built after the plan was refused. (Cambridgeshire Collection)

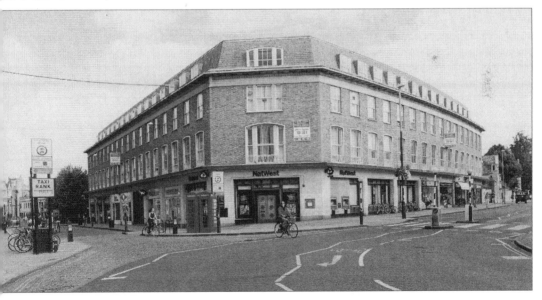

St Andrew's Street, 2000. Prudential Insurance took over the site and in 1959 completed a block of offices with ground-floor shops. Writer on architecture Nikolaus Pevsner was somewhat harsh in his judgement: 'It might be anywhere and would be noticed specially nowhere.' Another offered the comment 'overbearing bulk and overbearing and unvarying pomposity'. (Tony Jedrej)

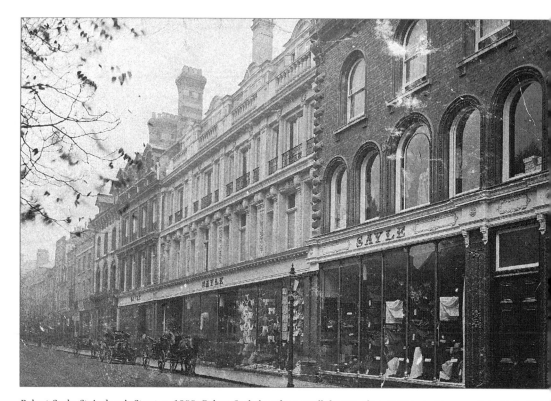

Robert Sayle, St Andrew's Street, *c.* 1900. Robert Sayle bought a small drapery shop at Victoria House on this site in 1840 selling goods for ready money with a small profit margin rather than on account. He refused to bargain or haggle and his window displays actually had the prices marked. The store grew and grew; departments, ranging from funerals to a brewery, were added. When he died in 1883 the business was sold but kept the trade name, and eventually became part of the John Lewis Partnership. (*Cambridgeshire Collection*)

Opposite: Robert Sayle, 2000. The modern canopy sadly detracts from the fine frontage but redevelopment plans may bring restoration. The store still displays some important interior features such as the grand staircase and on the top floor the apprentices' accommodation is largely intact behind the dormer windows. There were twenty-six rooms for women and thirteen for men. Separate dining rooms accompanied the reading and billiard rooms. Cambridge-based department stores, such as Eaden Lilleys', Joshua Taylor's and the Co-op, have gone the way of all retailing and been swallowed by national companies or died. For many years it looked as though John Lewis would move to an out- or edge-of-town site but the current Grand Arcade redevelopment should secure its future in the city centre. (*Tony Jedrej*)

A header for a bill, Robert Sayle, *c.* 1910. The telephone number is a reminder of the communications revolution which occurred at the beginning of the twentieth century. The Cambridge Folk Museum has a telephone directory from the early 1900s which has only 64 entries. By 1914 there were over 1,200. But if approached by a salesman, would you have been first to buy a telephone, and who would you have rung up? (*Cambridgeshire Collection*)

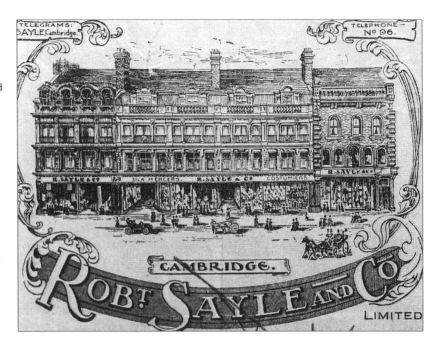

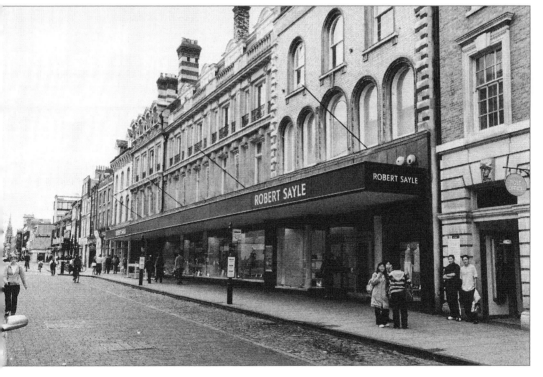

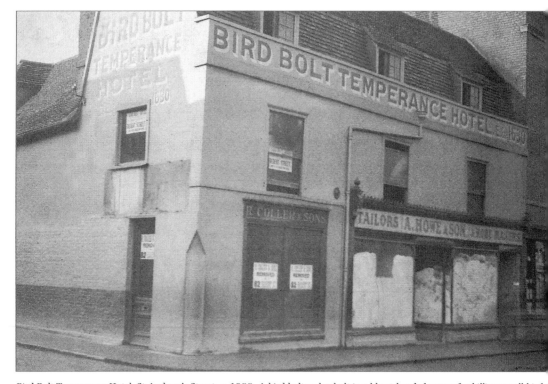

Bird Bolt Temperance Hotel, St Andrew's Street, *c.* 1900. A bird bolt or burbolt is a blunt-headed arrow for killing small birds without causing too much damage to the meat. The *Oxford English Dictionary* has a memorable quotation in its definition. 'You can never make a bird-bolt from a pig's tail.' Downing Street on the return frontage was once known as Bird Bolt Lane and earlier Dow Divers Lane. This ancient inn had become a temperance establishment but, by 1900, it was closed and about to be demolished. There had once been a front carriage entrance but this had been stopped up during the conversion to retail. The site once belonged to St John's Hospital and later St John's College. (*Cambridgeshire Collection*)

The Norwich Union Building, 2000. Is it something about the investment patterns regarding our pension and insurance funds which produce buildings for which we have such low regard? (*Tony Jedrej*)

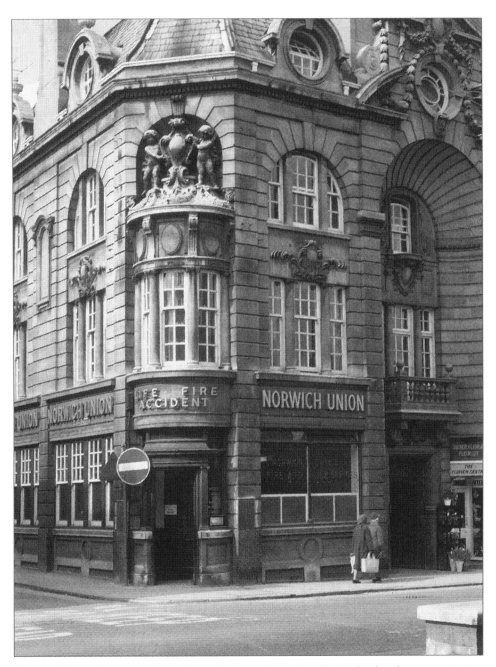

Norwich Union, *c.* 1970. It seems incredible that any organisation should want, let alone be given permission, to demolish such a fine example of an Edwardian office block. At least the statues above the door were saved and repositioned on the entrance to the rear of the new building. The architect was G.J. Skipper of Norwich, who also designed extensions to the University Arms. (*Norman Mason-Smith*)

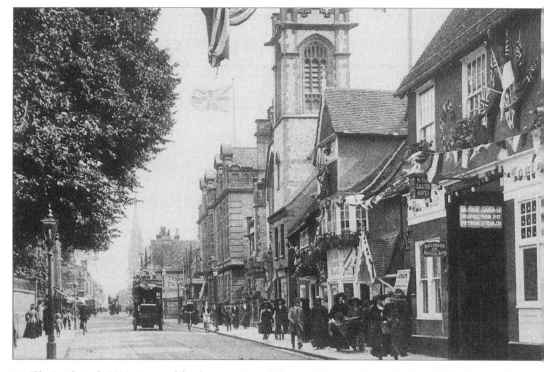

Ye Olde Castel Hotel, 1911. Decorated for the coronation of George V, it was originally built as Rudd's Hostel and was an early example of a university building in use before the foundation of colleges. It is believed to have been built before 1243 and remodelled in about 1620. Note the sign for the motor pit and the storage of petrol. Early motoring was conducted on rough roads so facilities for repairs were essential as was access to fuel, which was not as commonplace as it is today. In 1903 the Castel also advertised itself as a 'Telephone Call Office'. (*Cambridgeshire Collection*)

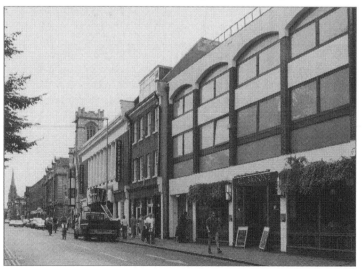

St Andrew's Street, 2000. In 1937, after a disastrous fire destroyed Ye Olde Castel, a new cinema arose from the ashes and an accompanying pub called the Castle. The Regal, or ABC as it was later known, traded for over sixty years but then succumbed to multi-screen competition. It was converted to become one of the largest pubs in the country and also provided a home for the Cambridge Art Picture House, which moved from the old Arts Cinema in Market Passage. Next door, Belfast Linen became the All-Bar-One. Other buildings that have been converted into pubs include the former January House offices in Downing Street, which are now the Rat & Parrot. (*Tony Jedrej*)

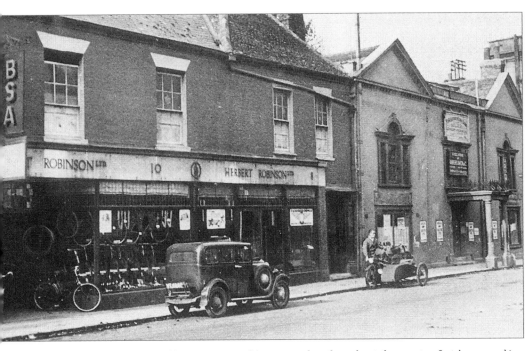

gent Street, 1932. Herbert Robinson, like many successful motor traders throughout the country, first began working cycles but within six years graduated to motorcycles and then cars in 1909. In 1932 he also had a foot in two streets cause his premises next door to each other were 2 Regent Street and 44 St Andrew's Street. The building with the porch s a pub, the Fountain Vaults, when this picture was taken. It had previously been Llandaff House, which itself stood on e site of a former inn, the Bishop Blaize. (*Cambridgeshire Collection*)

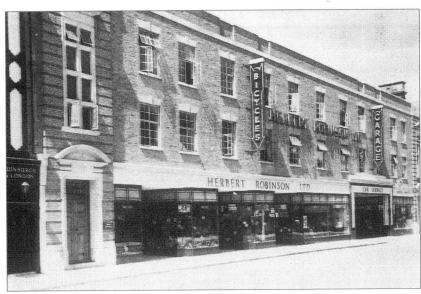

gent Street, 34. Purpose-built owrooms and raging replaced the nverted shops and e two floors of offices ere known as Llandaff hambers. The Fountain as also rebuilt t because it was positioned to the south the car showrooms ther than to the north actually moved from Andrew's to Regent reet. (*Cambridgeshire ollection*)

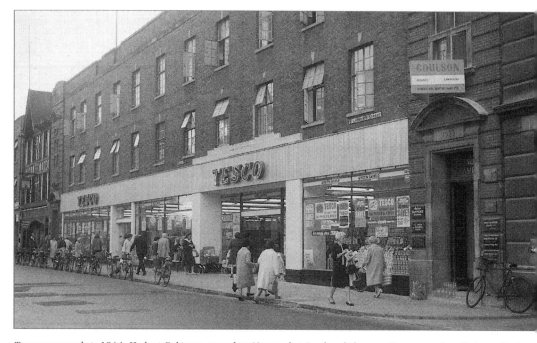

Tesco supermarket, 1964. Herbert Robinson moved to Newmarket Road and the new Tesco store heralded a radical mc from small grocery stores to self-service supermarkets. However, the absence of a car park by the front door was a ma drawback and in 1983 Tesco moved out of town to the new village of Bar Hill. (*Norman Mason-Smith*)

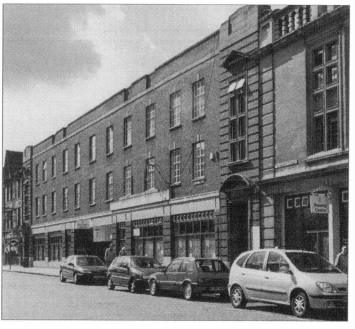

Mandela House, 2000. The city coun owned the freehold and when Tesco moved out the council itself moved in and named the block after Nelson Mandela. The top two floors, Llandaff Chambers, are now used as voluntary sector offices. In the foreground is the former police and fire station, built on the site of the old Spinning House in 1901. This had been made obsolete by the Vice-Chancellor's concession not to exercise the right to arrest, try in private and imprison prostitutes in 1894. When the police and fire brigac moved to Parkside, the council took over Hobson House for its housing department. It was owned by Hobson Charity which originally constructed the Spinning House or workhouse for the unemployed and as a house of correction for rogues and vagabonds. This was demolished in 1898 and replaced by the current buildings. (*Tony Jedrej*)

[R]ent Street and the Catholic church, *c.* 1900. Regent [Stre]et was named after the Prince Regent, the future George [I. I]t became a major retail street when the railway station [wa]s constructed 1 mile outside town. The Catholic church [wit]h its distinctive clock has become a major city landmark. [*Ca*]*mbridgeshire Collection*)

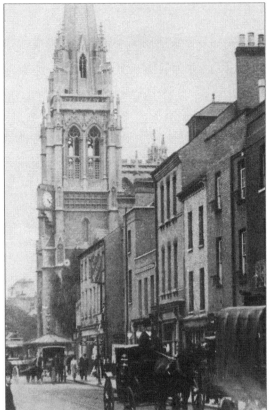

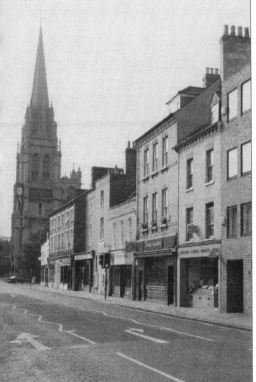

Regent Street, 2000. The Church of Our Lady of the Assumption and English Martyrs, commonly called the Catholic, was built in 1885 with £70,000 provided by a single benefactor, Mrs Lyne-Stephens. As Pauline Duvernay, a French ballet dancer, she was the toast of London but gave up her career when she married a man who was reputed to be the richest commoner in England. The corner site was bought by the Duke of Norfolk; Lensfield House, the one-time home of Wilkins, architect of the King's College screen, had once stood there. The first Catholic church was sold to St Ives. (*Tony Jedrej*)

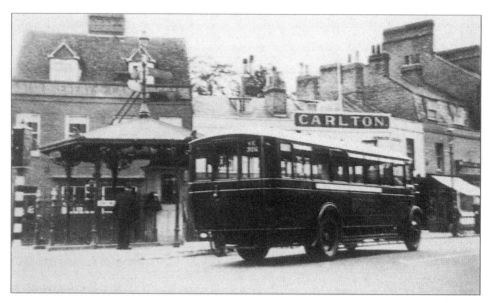

Hyde Park Corner, at the junction of Lensfield Road, Gonville Place, Regent Street and Hills Road, *c.* 1930. In the background are two pubs, the Carlton and the Royal Oak. In the foreground is a charmingly elegant structure – the canopy for the underground toilets. Perhaps because public conveniences were a relative novelty, the Victorians built them with a certain sense of style. (*Cambridgeshire Collection*)

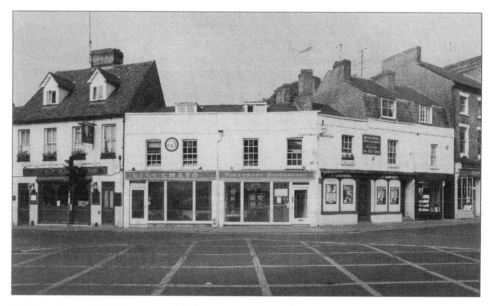

Hyde Park Corner, 2000. The name of Hyde Park Corner is another Cambridge mystery. A letter to the local paper suggested that one of the Hydes of Dinton, Wiltshire, married a Miss Peck and their house was on the corner. Traffic lights dominate the street scene. The Royal Oak is now called Lawyers but the Carlton has not survived as a pub. (*Tony Jedrej*)

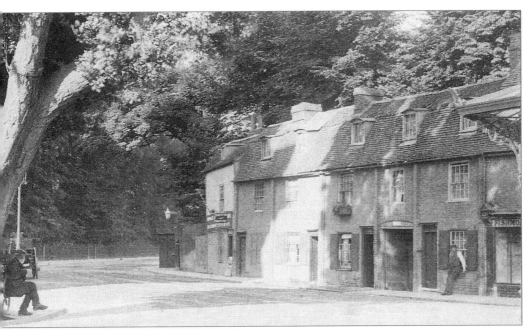

...gent Street, Hyde Park Corner, *c.* 1900. There sits the fictional commentator mentioned in the introduction to this book. ...ese buildings are considerably older than others in the area and when developed would have been somewhat isolated. ...is land is freehold of the city council let on a long lease from 1816: this may be another of Mayor John Mortlock's ...ock-down sales to one of his political cronies which left the city with an interesting legacy in the built environment. (*...ambridgeshire Collection*)

...nsfield Road, Hyde Park Corner, 2000. ...nsfield Road was named after John ...ns, a local landowner. Its former name ...s Deepway. For some reason this street ...d a higher than average population of ...ntists in the 1970s so the author has ...ways considered this the street of pain. ...e buildings have altered little but their ...cupants have changed. In 1903, when ...s was considered part of Regent Street, ...e range was partly empty but included ...hairdresser, carpenter and fishmonger. ...ius Wehrle, watchmaker, was sandwiched ...ween the Carlton and the Oak. By 1933 ...ehrle had been replaced by another ...atchmaker's, and other businesses ...cluded a greengrocer, upholsterer, boot ...d shoe repairer, window cleaner and ...ll a hairdresser. In 1968, they included ...confectioner, florists, antique dealers, a ...fé and health food store, but Page's, the ...atchmaker's, still existed. The Carlton had ...come Achille Serre cleaners. (*Tony Jedrej*)

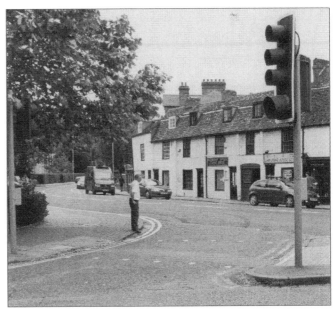

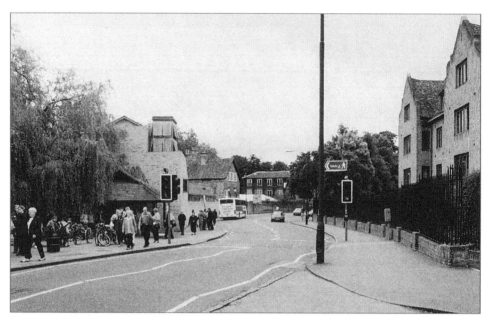

Hills Road, 1922. This road led to some real hills named after mythical gods Gog and Magog, commonly known as the Gogs. Next to Hills Road Wesleyan Church is the Dorset Temperance Hotel. Further up the road was a pub named the House of Commons. (*Cambridgeshire Collection*)

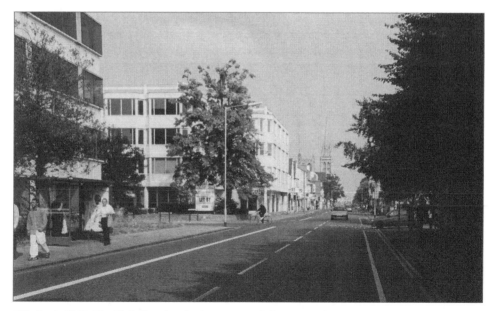

Hills Road, 2000. The Methodist church, the Dorset and the House of Commons have all gone from this section of road to be replaced by Three Crowns House and two other office blocks. Thankfully trees are the dominant feature in the picture. (*Tony Jedrej*)

Bateman Street, *c.* 1900. This was a new street in 1900; it was laid out to accommodate these large town houses in the late nineteenth century. It was named after William Bateman, a fourteenth-century Bishop of Norwich, founder of Trinity Hall and co-founder of Gonville Hall. And that stuff on the road is good for the roses! The photographer obviously considered it normal because he still took the picture. (*Cambridgeshire Collection*)

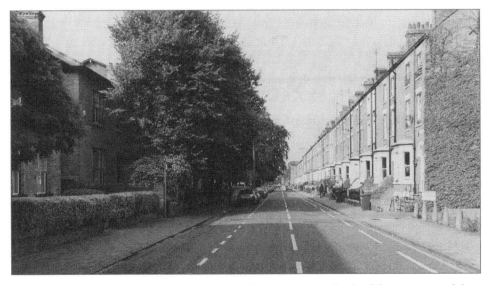

Bateman Street, 2000. Little seems to have changed, although on the south side of the street some of these large properties have been adapted to commercial and educational uses. The bridge over the Little New River or Hobson's Conduit, at the far end, was opened in 1884 and, given local concerns regarding traffic calming, residents may now be keen to see it closed. There have been plans to run trams to the end of the street for connection by viaduct to Barton Corner. (*Tony Jedrej*)

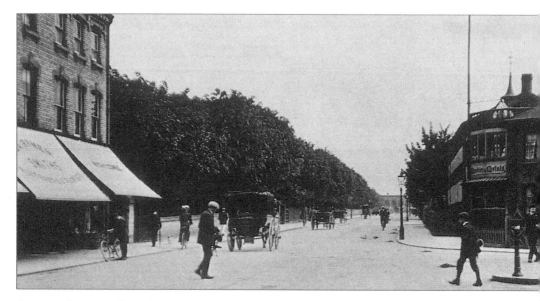

Station Road, c. 1900. The road was lined on both sides with grand town villas and houses largely obscured by trees. On t right is the corner of the little house of James Rattee, who began a building partnership with George Kett to form Rattee & Ke The building on the left, which continued around the corner, included the small Great Northern Hotel. Cambridge was not be blessed with large railway hotels because none of the five railway companies that served the town had a large share of t market. Fosters Mill was one of the first buildings to cluster around the station. Inside the station there was a branch of W Smith. (*Cambridgeshire Collection*)

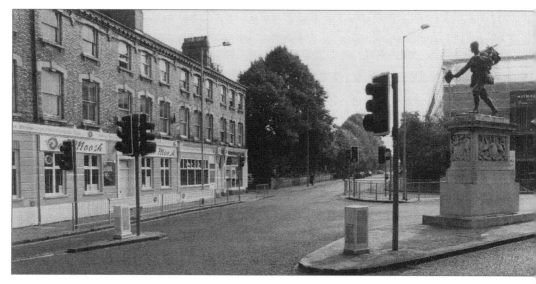

Station Road, 2000. James Rattee's house and the builders yard were replaced by Kett House in 1961 and all the villas the right-hand side of the street made way for large office blocks in the late 1960s and early 1970s. The junction is no dominated by the war memorial, a soldier returning home and looking back to see who has not made it. Sadly, the oth feature is the street furniture, mostly the intrusive traffic lights. (*Tony Jedrej*)

70

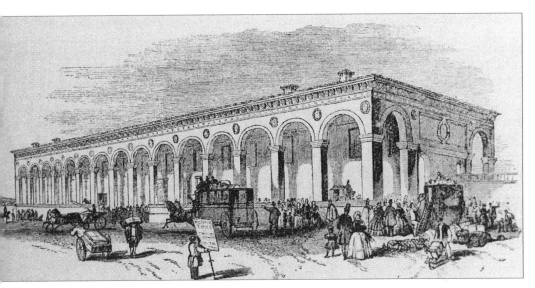

..mbridge station, 1845. In the nineteenth century, unlike today, the university did not embrace new technology willingly and ..led the railway station to 1 mile outside the built-up area. As a result the town grew towards the station and the cabman ..anked the university for its foresight. Because they were concerned about the possibility of students visiting the fleshpots of ..ndon, college officials were empowered by an act of parliament to halt trains and remove any undergraduates even if they ..d bought a ticket, although there is no record of the right ever being exercised. There were no trains on a Sunday between .. a.m. and 5 p.m. In 1851 the vice-chancellor wrote to protest against excursions which 'convey foreigners and others to ..lict their presence on the university and its day of rest'. The ban was not lifted until 1908. (*Cambridgeshire Collection*)

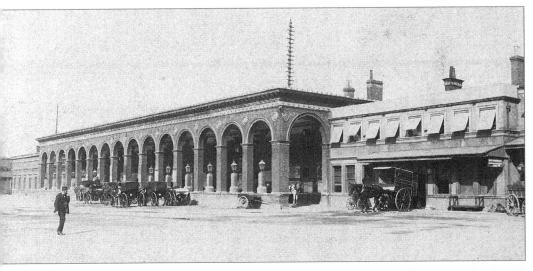

..mbridge station, *c.* 1900. The original arched building with college motifs has received some additions. Note the telegraph ..bles which, via the railway, brought the first national communication system and standardised time. Trains to London ..ere reasonably fast and often achieved it in seventy minutes as opposed to fifty-five today. There was reputed to be some ..obbery regarding which route was taken. If you were gown, you would always go by Great Northern to King's Cross, ..hereas the Great Eastern to Liverpool Street was the town line. (*Cambridgeshire Collection*)

71

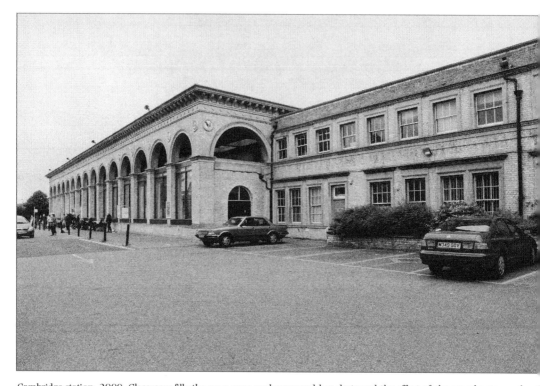

Cambridge station, 2000. Glass now fills the once open archways and has destroyed the effect of the grand entrance logg
although the age when a traveller had his coachman meet him off the train has long gone. The amount of land devoted
railway uses is reducing because of the decline in rail freight and line-served industries. That decline has brought forward t
possibility of alternative land uses because the need for giant goods yards has gone. Despite the loss of small feeder bran
lines, the proximity to London facilitated by electrification and airline-style comfort has given the railway a new lease of li
(*Tony Jedrej*)

Parker's Piece to Romsey Town

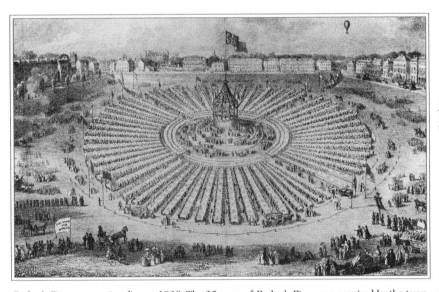

Parker's Piece, coronation dinner, 1838. The 25 acres of Parker's Piece was acquired by the town
in 1613 after an exchange with St John's College for land on the Backs at Garrett Hostel Green.
Edmund Parker, a college chef, was the lessee at the time of the transaction, so by accident rather
than design his name was immortalised. One of the most spectacular events on the Piece was
Queen Victoria's coronation dinner. A crowd of 15,000 sat down to consume 7,029 joints of
meat, 4,500 loaves of bread, 1,608 plum puddings and 99 barrels of ale with large quantities
of mustard, salt, pickles, tobacco and snuff. Men had three pints of ale, women one and
children a half. There followed a balloon ascent and at night a grand firework display by
Mr Deck, a local chemist. Some party! The logistics involved in organising an event on such
a scale make Cambridge's millennium party for 30,000–40,000 look like a simple operation.
(*Cambridgeshire Collection*)

University Arms Hotel, 1909. The original hotel dates from 1834 when John Barefoot transferred the licence of the Greyhound Inn in St Andrew's Street to this site. After being kept by the sisters Hewitt for much of the nineteenth centur it was taken over by a young college chef, Marcus Bradford, who had failed to win the franchise which had been held by h recently deceased father because the college believed he was too young. He added more accommodation in 1894 and aga in 1909. (*Cambridgeshire Collection*)

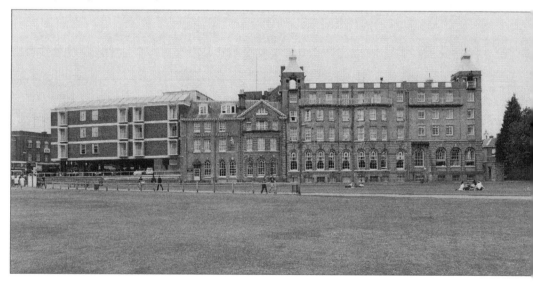

University Arms Hotel, 2000. The large back section topped by the water towers was added in the late 1920s and '30s. the 1960s the front section of the hotel was demolished to make way for the brand new saw-tooth-style block to front Regen Street. This provided more car parking and modern accommodation to cater particularly for American tourists. Ironically, a old building was destroyed to create a new one so that it would attract people who came to see old buildings! (*Tony Jedrej*)

n gaol, *c.* 1870. Gonville
e was once the site of
clay workings which
e used for plague pits or
s graves in 1574. Built
828 on part of Donkey's
mon, the gaol could hold
to forty-eight prisoners.
unately for the leisure
s of the Piece, this
r building was removed
years later and the
onsibility for prisoners
transferred to the county
on Castle Hill, although
was also closed, in 1915.
osted only one hanging.
nbridgeshire Collection)

een Anne Terrace, 1910. This grand red-brick terrace faced Parker's Piece. Built in 1880 and occupied on 75-year leases,
hin twenty years the twelve houses were owned by only two people. Two remained as private dwellings but part of the
race became Burlington House, the University Correspondence College, and the Ministry of Health occupied part of the
nainder along with the United Cambridge Hospital Nurses Hostel. The terrace was reputed to have been badly fractured
vibration from wartime bombing and was said to be beyond repair when it was demolished in the late 1960s. The pair of
ck piers that provide the gate for Owen Webb House, once the County Farmers' Club, still remain. The YMCA occupies the
w Queen Anne House and was itself displaced from its 100-year-old premises in Lion Yard by the new shopping centre.
xt door is an ugly car park and the Kelsey Kerridge Sports Hall. (*Cambridgeshire Collection*)

Parker's Piece from Regent Terrace, *c.* 1900. Regent Terrace was once a private road and ran along the back of Regent Str⟨
Much of the land was owned by the corporation and Mayor John Mortlock took advantage of his position to sell some o⟨
cheap to his political associates. Several of the buildings were also constructed over Hobson's Conduit. If the sale had
occurred then Parker's Piece would have been even larger and open to the street, without the untidy collection of buildi⟨
along much of the terrace. *(Cambridgeshire Collection)*

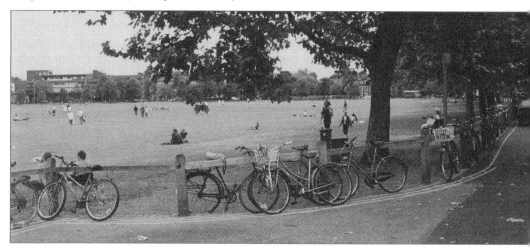

Parker's Piece, 2000. This view shows the sports hall and car park with the YMCA to the right. Parker's Piece remair⟨
rough ground until 1831 when parts were levelled 'for the manly game of cricket'. Cambridge was to play a major part ⟨
the Victorian game with local players such as Tom Hayward and Jack Hobbs becoming household names. The Piece is a⟨
famous as the home of association football, Cambridge rules having been adopted in 1863. The 1848 game when stude⟨
were said to have first nailed the rules to a tree was recently re-enacted. Skipping was also a popular pastime at Easter b⟨
this did not catch on as a national sport. It was more of a boy meets girl event and it was a custom which did not surv⟨
the social changes brought by the Second World War. *(Tony Jedrej)*

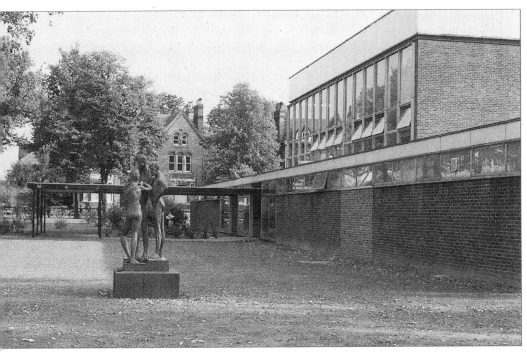

rkside Pool, *c.* 1975. A pool was first discussed in 1931 but at the time it was agreed to take no further action. The issue s raised again in 1950 but held up by delays in Whitehall. The pool eventually opened in 1963 and featured a large saic given by the former local MP, Hamilton-Kerr. This was salvaged and redisplayed in the new pool, opened in 1999. blic subscriptions were given for the statues of naked swimmers, designed by Betty Rea but completed after her death. ey raised more than a few eyebrows at the time, but few would bat an eyelid forty years on. (*Norman Mason-Smith*)

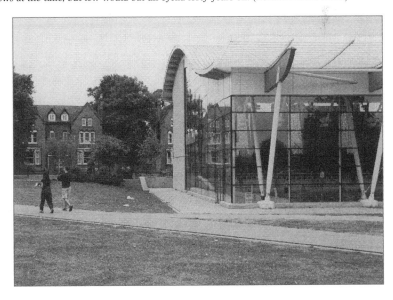

rkside Pool, 2000. Political ntroversy raged over the aintenance of the old pool, e cost of refurbishment or placement and the immoral e of what some regarded as mmon land. Government red be combined with all these tors to delay a decision about e pool's future. Success in racting a massive National ttery grant allowed the velopment to proceed and sured that a large part of nkey's Common would remain en space. The distinctive curved of is made of gluelam from rmany and is believed to be the rgest single span of its type in rope. (*Tony Jedrej*)

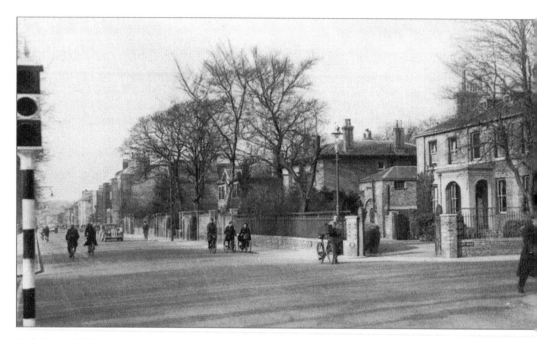

Parkside, *c.* 1930. Large town houses at the crossroads of Gonville Place, East Road, Mill Road and Parkside. Ea[r]
traffic lights were later replaced by a roundabout which was itself replaced by, you've guessed it, traffic lights! Coll[e]
developments around Parker's Piece focused on quality housing in the nineteenth century but now very few households n[e]
so much space for servants. As a result many of the buildings have been converted for student accommodation, business
institutional use. *(Cambridgeshire Collection)*

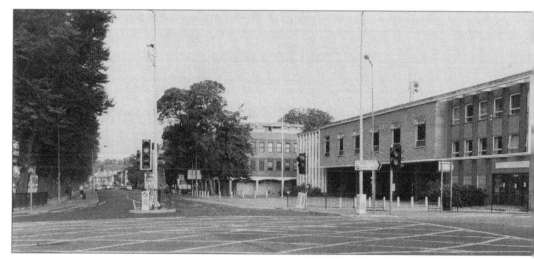

Parkside, 2000. Five town houses were replaced by the police and fire stations when they moved from St Andrew's Street
1963. But within thirty years the future of these sites was in question because of the access problems encountered in hea[vy]
traffic. Nothing lasts forever but some organisations barely seem to unpack before discussions begin again about moving. *(To[m]
Jedrej)*

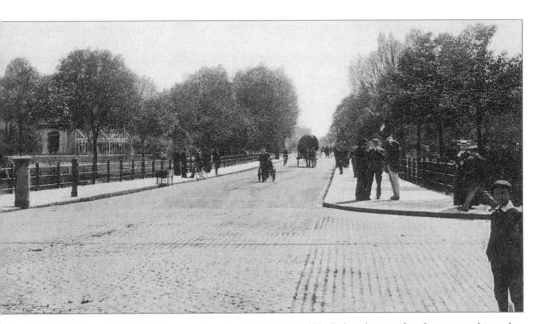

ll Road, 1905. If it wasn't for the footways and road surface there would be little indication that this was anything other
in a rural view. In fact this was a major road leading to one of the most populous working districts in the town. To the
t is Petersfield and Donkey's Common is to the right. Mill Road was named after a windmill which is long gone.
imbridgeshire Collection)

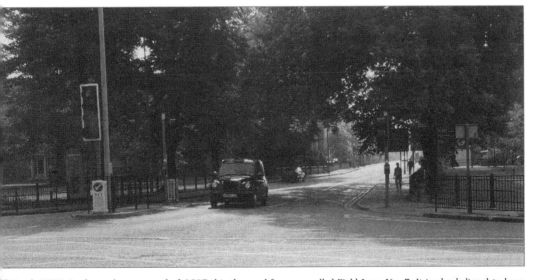

ll Road, 2000. In the enclosure award of 1807 this thoroughfare was called Field Lane No. 7. It is also believed to have
en called Hinton Way until, after enclosure, it gained a new name from the mill that stood at what became the junction
th Covent Garden. The mill was rebuilt in 1792 by Charles Humfrey and was then known as the Corporation Mill, but in
;40 the sails were blown off in a gale and after some years the body was removed. Trees still provide a pleasant entrance to
e road. (*Tony Jedrej*)

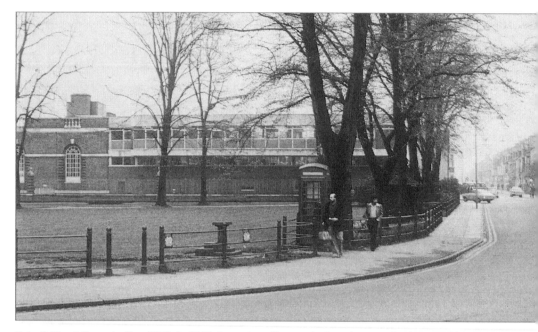

Petersfield and the post office, 1978. In 1935 the sorting office was built in the grounds of Petersfield Lodge which had one time been home to a former mayor. The post office engineering department had already taken over the house and in ┇ 1960s it was demolished and replaced by an administration block. (*Norman Mason-Smith*)

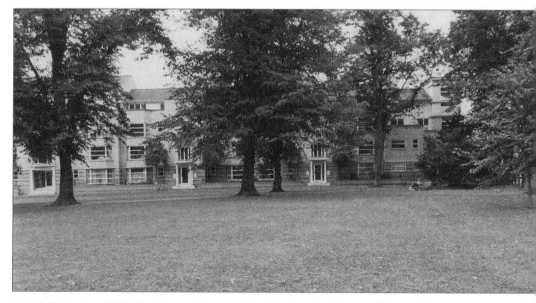

Petersfield Mansions, 2000. The site reverted once again to housing when the post office moved out to an industrial esta┇ but the properties are now worth a little more than those demolished in the 1960s. After years of expansion and plannir policy which moved people out of town centres, the tide had turned. (*Tony Jedrej*)

Playhouse, Mill Road, 1912. The invention of film brought moving images of the world into the lives of people who would probably never see them in reality. The Playhouse was Cambridge's first purpose-built cinema and its distinctive red brick with white panels gave it an attractive frontage. It seated 769, including 167 in the balcony. The first film shown portrayed the theft of a workman's lunch. It lasted nine minutes and was called *Hustling in Cambridge*. (*Cambridgeshire Collection*)

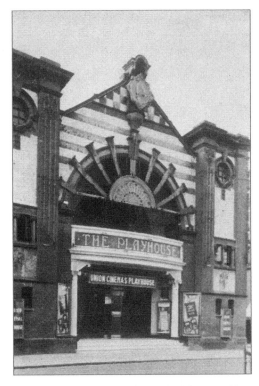

Below: Playhouse interior, *c.* 1930. Unfortunately government entertainment taxes ate into cinema profits and the Playhouse closed in 1956. Incredibly, the owners ripped off the front of the building but saved the back! A new building was erected inside the old and a new front was added. (*Cambridgeshire Collection*)

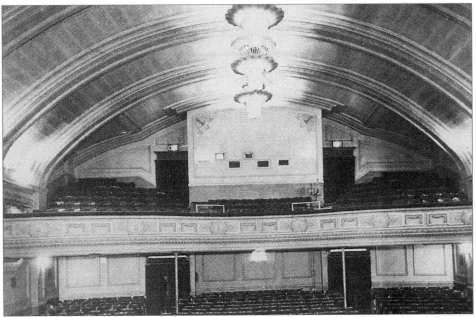

81

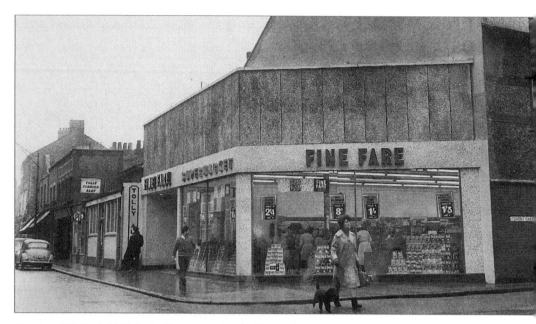

Fine Fare, Mill Road, 1970. Looks like a wet and miserable Monday morning. The supermarket, like its competitor Tesco Regent Street, opened in 1963 but by 1985 the Salvation Army had taken the building over. The wall to the right is ne to where cinema patrons would queue and some scratched their names in the brick. Others admit to having rubbed th farthings into the mortar to try to make them look like sixpences! *(Cambridgeshire Collection)*

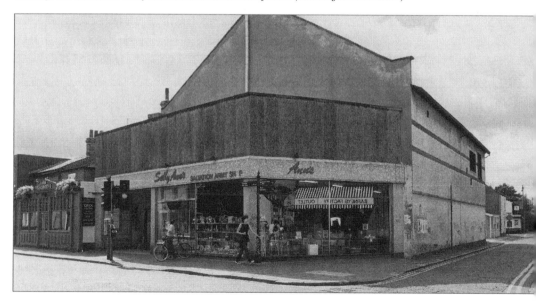

Sally Ann's, Mill Road, 2000. The former playhouse is now a popular secondhand or 'pre-owned' shop run by the Salvati Army, which also has a community centre a short distance away and is a well-respected part of the local community. H different from the nineteenth century when demonstrators violently disrupted their meetings and marches. *(Tony Jedrej)*

workhouse, Mill Road, *c.* 1880.
was built in 1838 for the Cambridge
ion when several parishes combined
provide a joint scheme for poor
ef. The contemporary belief was
less eligibility', which meant that
iditions inside the workhouse
iuld be worse than those outside
ierwise no one would leave. Such
·sh political sentiments often failed
their application not just because of
fact that if conditions were worse
ide, who would enter, but because
local guardians often subverted
brutal regime. For many this was
first contact they had with medical
vices and by 1906 the Poor Law
irmary was developed. In 1948 the
tional Health Service took over the
for use as a maternity hospital.
imbridgeshire Collection)

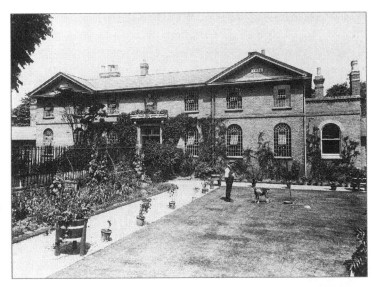

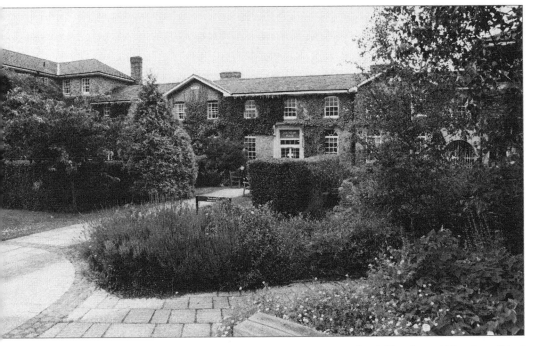

ichburn Place, Mill Road, 2000. The maternity hospital welcomed many a Cambridge child to the world but the staff had
overcome the difficulties inherent in working in converted buildings. However, local benefactor David Robinson, who made
s money from television rentals, gave £3 million for a new maternity hospital at New Addenbrooke's on condition that it
as named the Rosie after his mother and that it was open by 1983. The City Council bought the Mill Road site for care
nits and supported housing but retained the old frontage. Ditchburn was the surname of the last master and matron of the
irkhouse. (*Tony Jedrej*)

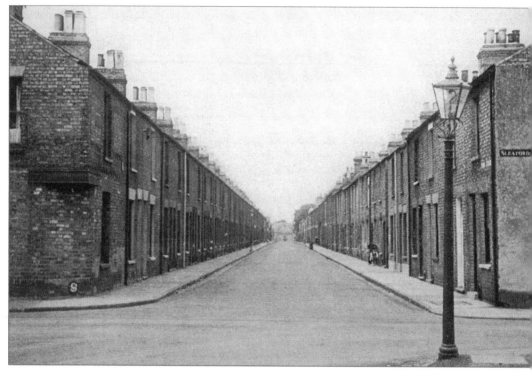

York Street, 1950. This is a good example of the terraced streets off Mill Road – mostly housing but with some sm businesses either in rear sheds or side units. In 1895 those living here were predominantly railwaymen, constructi workers, craftsmen, labourers and shop workers. *(Cambridgeshire Collection)*

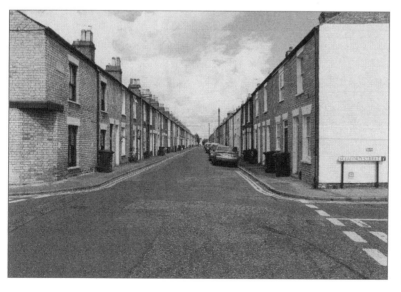

York Street, 2000. Plans were made to clear the area and build new roads but they cam to nothing. Now these areas a sought after by people whose income levels are far higher than those who first inhabited them. The most visible difference from 1950 is the lor row of cars and wheelie bins. And throughout the area mos of the corner shops have close *(Tony Jedrej)*

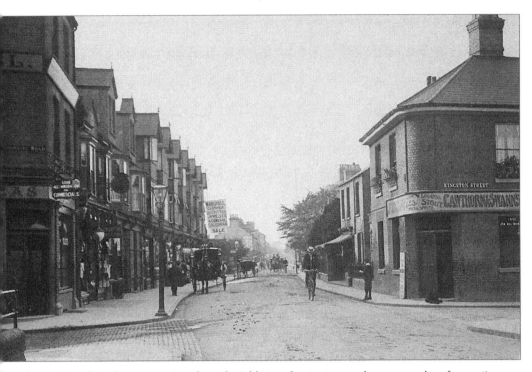

l Road, c. 1900. Mill Road was once primarily residential but as the streets around grew a number of properties were
verted by adding shopfronts over the front gardens. The section on the left was purpose-built with accommodation above.
e corner building was the Great Eastern Temperance Hotel, the 'cyclists' rest'. Next door was Swiss House and Smarts &
1 outfitters, who also had premises on Market Street. On the right stands the White Swann, from the brewery of Cawthorn
wann. *(Cambridgeshire Collection)*

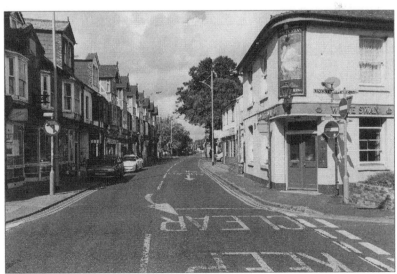

ll Road, 2000. Little has
anged in 100 years, apart
m the shopfronts and
tree growth. Despite
anges in retailing, increase
car ownership and the
itrification of former
rking-class and artisan
mes, Mill Road has survived
a vibrant shopping area.
is is Sturton Town, named
er the chemist Joseph
irton, who developed much
perty in the area.
ny Jedrej)

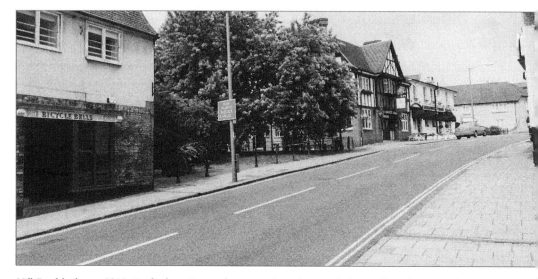

Mill Road bridge, *c.* 1910. By the late nineteenth century dense housing had spread rapidly across the railway line. W heavy mainline rail traffic the level-crossing was closed so often it caused too many delays for wheeled traffic and in 189 was replaced by a bridge. The pedestrian bridge was rebuilt on Stourbridge Common and when electrification brought abo the need for a replacement it was donated to the North Norfolk Railway Museum. The houses either side were built prior the bridge so their aspect was changed totally – the footpath ran at the same height as the bedroom windows. On the left the Earl of Beaconsfield pub and just beyond is a small shop, which reputedly never closed because it served railway work on night shift. *(Cambridgeshire Collection)*

Mill Road Bridge, 2000. This photograph was taken looking down the bridge into Romsey Town, named after Romsey Hou which still stands at the junction of Mill Road and Coleridge Road. But the origins of its name are obscure: yet anoth Cambridge mystery. It could have been worse – one of the first landholdings in the area was Polecat Farm! *(Tony Jedrej)*

Barnwell to Chesterton
via the Grafton

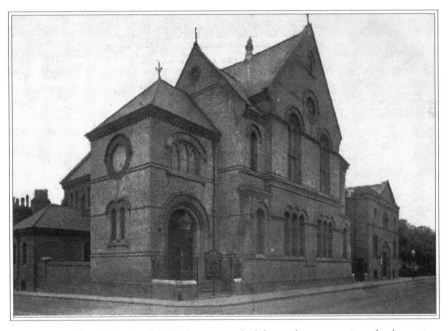

Zion Baptist Church, East Road. 1907. In an area which has undergone massive redevelopment
Zion remains a rock in a sea of change; the only difference in its appearance now is that it
has lost its railings. The Zion Baptist was begun in 1838 – the more modest of the two distinct
buildings – and was formed by a dissenting group from the Eden Chapel. As dense housing
engulfed the once open countryside the church looked to expand and built the second of the two
churches in 1878. Postwar, inner-city decline led to a dwindling congregation and road widening
schemes threatened the Zion's very existence. However, both buildings are now listed and host a
number of social projects. *(Cambridgeshire Collection)*

Coulson's and the White Ribbon, East Road, 1978. Coulson's & Lofts began trading on what was once called Gravel Pit Road
the late nineteenth century, and developed into one of Cambridge's leading builders. Proposals for an extension to the Graft
Centre brought about their relocation in 1988 to Cowley Road. Next door is the White Ribbon Temperance Hotel, a Salvati
Army night shelter. It began life as the Barnwell People's Coffee Palace in the late nineteenth century, an alternative to t
numerous pubs in the area. Between the White Ribbon and Coulson's runs Crispin Place. In 1853 a commentator wrote, 't
abodes are cheerless, squalid . . . the occupants are for the greater part idle, dissolute characters. The men are known to t
police; the women live, and partly support their paramours by perpetual dishonour.' (*Norman Mason-Smith*)

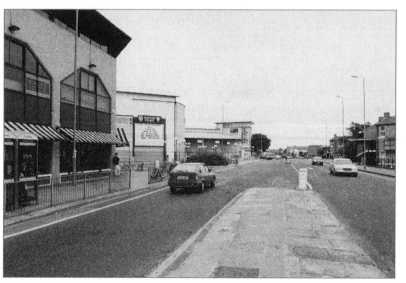

East Road, 2000. Beyond
Abbeygate House, the road
opens out to the interchan
serving the Grafton Centre.
The cinema welcomes
patrons to the eight screen
while beyond is the BhS
store. Dualled in 1963 this
road, partly as a result of
closures elsewhere, has
become one of the busiest
routes across the city. The
housing on the right has
a distinctive 1960s zig-zag
arrangement and was the
first major result of slum
clearance undertaken by th
council. (*Tony Jedrej*)

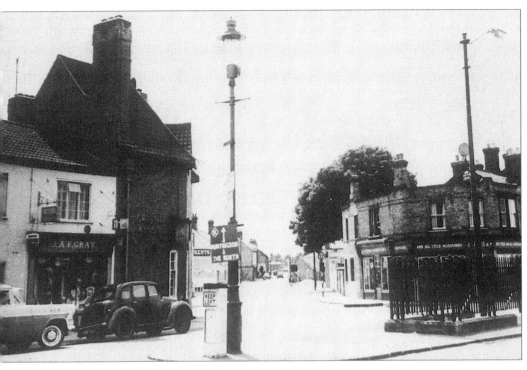

st Road junction with Newmarket Road, 1962. This was once the centre of the small and pleasant village of Barnwell, the ¬me being derived from 'beorn' or 'warrior's well'. This tiny hamlet, which stood on the doorstep of the wealthy Barnwell ¬ory, was swamped by enormous and rapid housing growth in the nineteenth century, much of it poor quality. The district ¬s so notorious that some residents refused to have the Post Office stamp their letters with its name, lest their friends ¬ow where they lived – little wonder given just one description of old Gas Lane as 'the receptacle of all the physical dross ¬ Cambridge'. Its two biggest industries were breweries and brothels and, as one local wag said, 'all the breweries are shut ¬w!' (*Cambridgeshire Collection*)

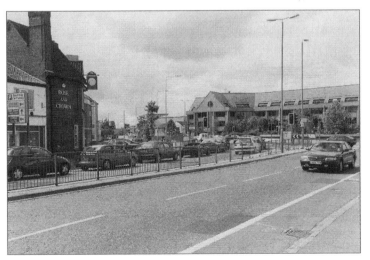

st Road, 2000. The buildings on the ¬, including the Rose & Crown, have ¬ survived but the dual carriageway ¬s punched a hole through the ¬ea to provide cleared sites for ¬velopments such as Compass House ¬ the right. The toilets guarded by ¬e railings in the previous picture ¬ve disappeared but are believed to ¬ still under the road. Gray's former ¬eetshop to the left, with its blue ¬ed front, has only recently been ¬novated. (*Tony Jedrej*)

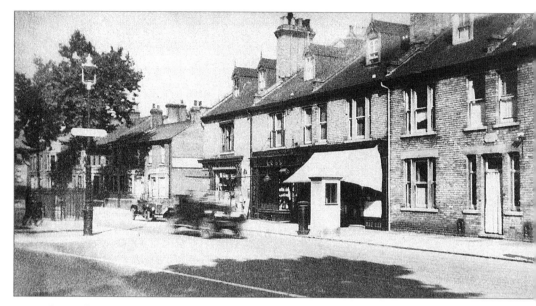

Newmarket Road, 1928. Newmarket Road, once called George Street, was the major thoroughfare to and from the ea
Although this part still had a sleepy feel to it between the wars, it was also the industrial sector of the town with tim
yards, brick pits and the gas works. Drink was always present. In 1903 Eglantine Jebb recorded that there was one p
for every 138 people compared to the national average of 230. Between Wellington Street and Hutchinson's Court
Newmarket Road there were twenty-two pubs, one every 36 yards! The students' King Street Run, involving a pint in eve
pub, would have been a crawl on Newmarket Road. *(Cambridgeshire Collection)*

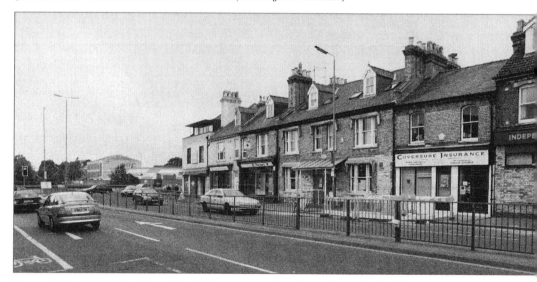

Newmarket Road, 2000. A whole section of the street was cleared to make way for the Elizabeth Way roundabout and th
third bridge across the Cam. Cambridge lost the quiet residential Walnut Tree Avenue and sixty-two houses to the deman
of the car. Despite the upheaval, this small stretch of the road has retained not only the doctor's surgery but also the chem
and the post office. *(Tony Jedrej)*

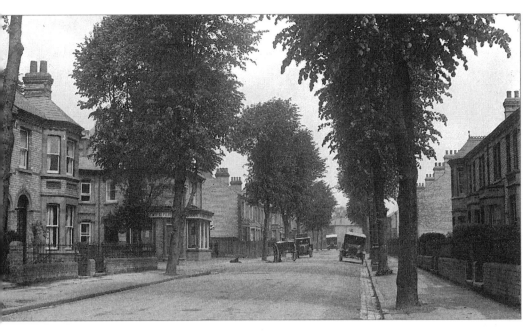

...n Road, *c.* 1920. Across the river in Chesterton, the residents of Cam Road, a peaceful suburban street, had little idea ...the fate that awaited it. The river was crossed by a chain ferry known as 'Dant's'. The public house, the Fleur-de-Lys, is ...rtially hidden by a tree. When Elizabeth Way was opened politician 'Rab' Butler found that the scissors wouldn't cut the ...bon, much like the opening of Victoria Bridge when the champagne bottle wouldn't smash. *(Cambridgeshire Collection)*

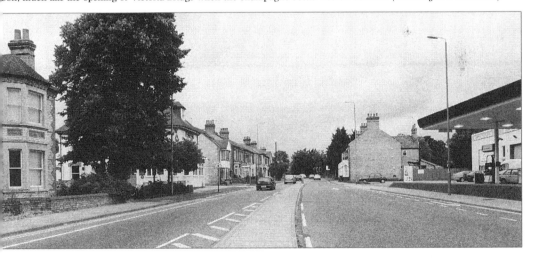

...zabeth Way, 2000. It was named after Queen Elizabeth II and opened in 1971. This crossing was first proposed as part ...the act of parliament that created Victoria Avenue. Despite the belief that Chesterton was promised the bridge in return ...cooperation with the borough extension of 1912, it took another sixty years before the new road became a reality. ...e buildings on the right have been swept away to make way for a petrol station, which was begun by Ted Salisbury in ...e 1930s in a shed next door to the Fleur-de-Lys. Although the left-hand terraces remain, their surroundings have been ...mpletely altered. Cambridge got its third river crossing but Cam Road was one of the casualties. *(Tony Jedrej)*

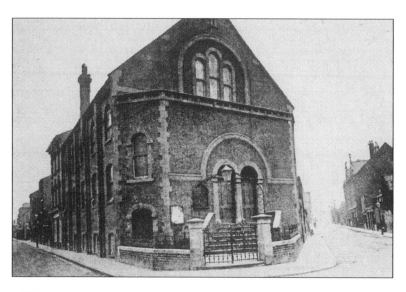

Eden Chapel, *c.* 1910. Built
at the junction of Fitzroy
Street and Burleigh Street in
1874, it survived the almost
complete transformation
of Fitzroy Street as it
was absorbed into the
Grafton Centre. It is now a
restaurant. Present church
members have benefited from
a modern replacement next
to New Square. This was one
of the first areas to expand
after the enclosure awards
and before the growth
of slums depressed the
optimism of the age which
was reflected in names such
as Garden of Eden, Adam &
Eve Street, and Prospect Row
(*Cambridgeshire Collection*)

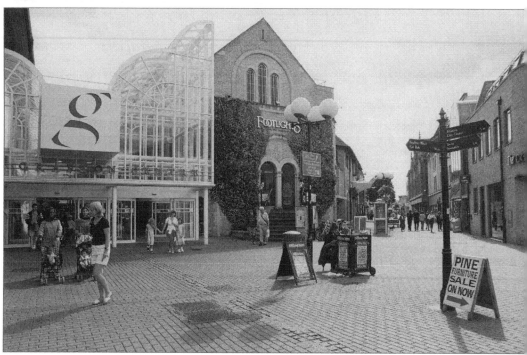

The Grafton Centre, 2000. Augustus Henry Fitzroy, 3rd Duke of Grafton, MP for Cambridge University (when it elected two
members) and Chancellor 1784–1816, gave his name to Fitzroy Street and subsequently the Grafton Centre. He wasn't
the only Grafton in Cambridge, though. A less aristocratic namesake, John Grafton, was the man who first brought gas to
the town in the 1820s. The success of the Grafton Centre has reinforced Cambridge's position as a shopping destination.
(*Tony Jedrej*)

leigh Street Co-operative Store, 1965. Burleigh
et is named after James Burleigh, a prominent
rier. The Cambridge Co-op began in 1869 when
roup of cobblers got together to provide cheaper
visions for working people. They moved around the
ner from City Road to Burleigh Street in 1882.
 business flourished and diversified and the
nbridge & District Co-operative Society was born.
r the next 100 years the society was to play a
jor part in the city and particularly in Burleigh
et. (*Norman Mason-Smith*)

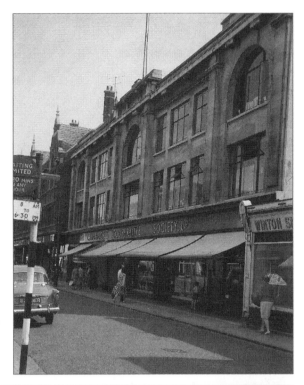

ow: Burleigh Street, Co-operative buildings, 2000.
the Co-operative Society's heyday members would fill
 assembly hall on the upper floor and the Co-op ran
ny educational and social activities. In the 1970s
 society branched out to the Beehive Centre, a
count warehouse which later became a superstore.
s overstretched the Co-op and ultimately brought
ut its downfall, with not only the closure of Burleigh
et but also the sale of the Beehive. The small corner
ps, the funeral director's and the car showrooms
de on. Sadly, this façade has now been replaced.
ny Jedrej)

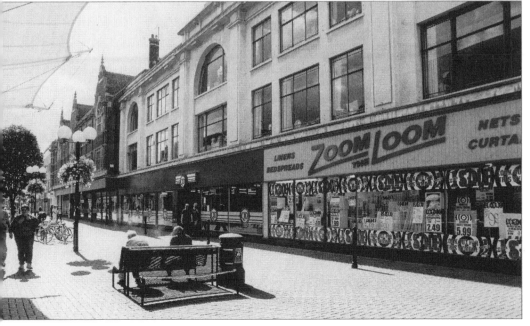

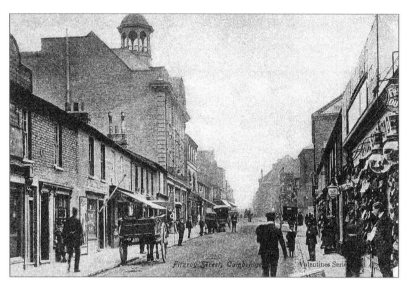

Fitzroy Street, 1903. The western end of what is now Fitzroy Street was once calle Eden Terrace and Blucher Ro the latter after the Prussian saviour of the British at Waterloo. By the turn of the nineteenth century the original cottage shops were being replaced with purpose-built units of gran proportions. On the left was the darling of them all, Lau & McConnell's department store, which took over an earlier store run by S.L. You In 1903 after a serious fire the store was rebuilt. It even had its own roof-top bandstand and tea garden. (*Cambridgeshire Collection*)

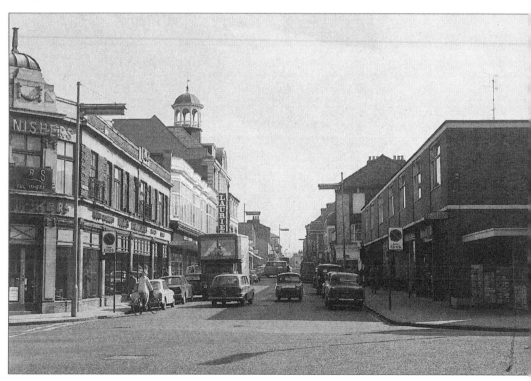

Fitzroy Street, *c.* 1975. The small-scale live-above-the-shop terrace was replaced between the wars, but in 1959 the oth side of the street was torn down to create the ugly box building, which remains today and was a portent of what was come. The architects designed Bradwell's Court for the same college, Jesus. (*Norman Mason-Smith*)

roy Street, 2000. Laurie & McConnell's, now occupied by Habitat, survived as one of only two original buildings naining in the whole of the street, the other being the Eden Chapel. The area is now pedestrianised. (*Tony Jedrej*)

w Square, 1930. These cows grazed in the middle of Cambridge but sadly they were about to give way to cars when the are was laid out as a car park. This view shows Rhadegund House with Short Street on the left. (*Cambridgeshire Collection*)

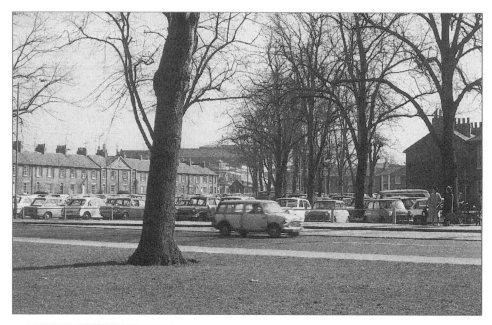

New Square, c. 1975. Cows have made way for cars. The square was laid out by Jesus College from the 1830s but only three sides were built. The terraces were largely occupied by university officials, lodging housekeepers and skilled craftsmen. *(Cambridgeshire Collection)*

New Square, 2000. The cows aren't back but the cars are gone. Part of the agreement for the construction of the Grafton Centre was that cars would be banished to the new multi-storey car parks. *(Tony Jedrej)*

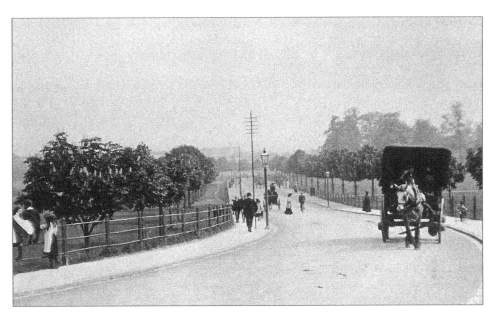

Victoria Avenue, *c.* 1900. Cambridge's second river crossing, the bridge opened in 1890 and replaced a chain or 'grind' ferry. The bridge was built with a tow-path even though the river trade was in decline. The new road was the first attempt at a bypass, on this occasion for the Magdalene Bridge bottleneck. In the distance is the Laurie & McConnell bandstand. *(Cambridgeshire Collection)*

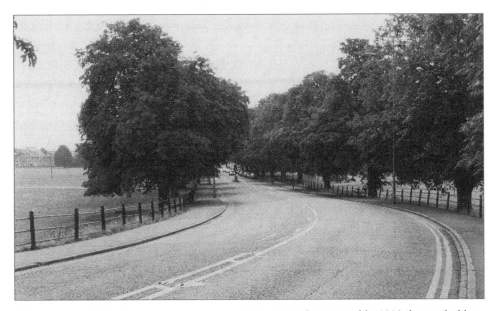

Victoria Avenue, 2000. The avenue was to open up Chesterton to the town and by 1912 the area had been absorbed into Cambridge. If the good people of Chesterton had only been aware of their fate, perhaps they would have fought against the bridge! *(Tony Jedrej)*

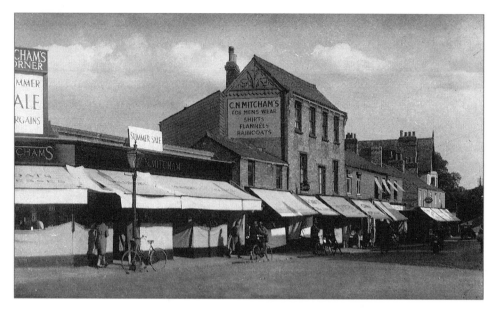

Mitchams Corner, Victoria Avenue, *c.* 1920. Mitcham's was a store that gave its name to an area of town. Established in 1909 selling materials for dress-making, it later expanded into supplying menswear, linens and soft furnishings. (*Cambridgeshire Collection*)

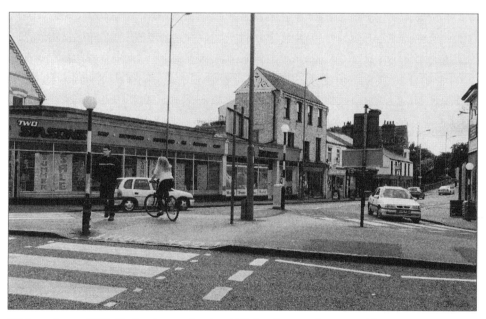

Mitchams Corner, 2000. Mitcham's store closed in 1977 but the name lives on in folk memory even though the title has no official recognition. A commemorative name plate would be appropriate – to replace some of the traffic signs which disfigure many a view, especially on this section of the inner ring road. (*Tony Jedrej*)

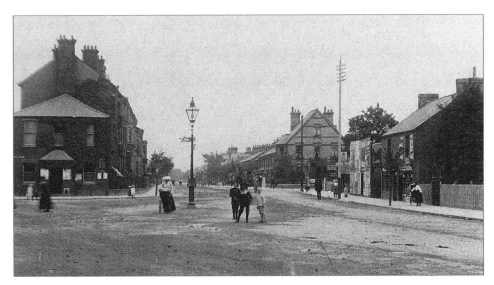

Chesterton Road, *c.* 1900. In front of the end of the large terrace were the offices of Chesterton Urban District Council. On the right can be seen the distinctive house which became part of Mitcham's store. On the corner of Victoria Avenue is the Jolly Waterman sporting the symbol of the Star Brewery – every river crossing had an associated public house. In 1850 it was said that this was the only building between Chesterton and Cambridge. (*Cambridgeshire Collection*)

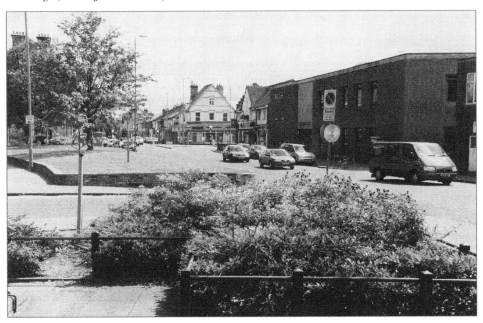

Chesterton Road, 2000. The open junction has been landscaped to help direct the traffic around the large one-way system. The brutal building on the right is Barclay's Bank, which replaced a typical small branch after 1974. (*Tony Jedrej*)

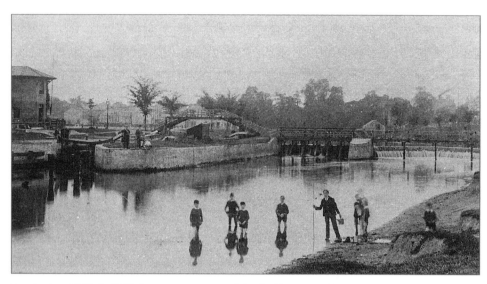

Jesus Lock, *c.* 1900. In 1836 the contract was awarded to build two new sluices and a house to replace those at the Fort St George. Jesus Green Lock was created and new tolls were implemented a year later. The lock kept the water levels up so that barges and boats could navigate to Quayside and the Mill Pond. The banks below the lock were unmade and shallow, and children could wade from them. In 1851 a new wooden bridge was constructed across the lock. (*Cambridgeshire Collection*)

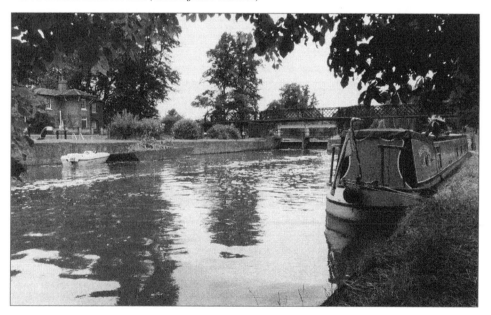

Jesus Lock, 2000. In 1892 a high-back bridge had been replaced by a higher but level version. Without doubt thousands of people pass this way each week and give little thought to the bargees and their families who would have toiled up and down river, transporting goods and providing the life blood of the city economy. (*Tony Jedrej*)

Barnwell Gate
to the Castle

Point duty, at the junction of St Andrew's and Sidney Streets, *c.* 1930. Every picture tells a story but some tell a longer story than others. For the first time, because of the extremely hot weather, a policeman was allowed on duty without his tunic. The local paper came to record the moment, but after publication the driver of the vehicle told the policeman that the woman in the car wasn't his wife! *(Cambridgeshire Collection)*

At Barnwell Gate, *c.* 1930. This is the junction of St Andrew's Street, Sidney Street, and Petty Cury. In the early Middle Ages this was a gate into the town but by 1573 only one post remained. To the right is Hobson Street; it runs on the line of the King's Ditch which ran to Wall's End, now King Street. The old post office is to the left and Lloyds Bank (once Foster's) to the right. On the corner of the Cury is Turner's chemist shop with Kittridge's tobacconist next door. The newcomer to the street is Boot whose new shop was set back from the original building line in 1930– to allow road widening. According to one commentator, it has a distinctive 'Fenland-Cotswold style' (*Cambridgeshire Collection*)

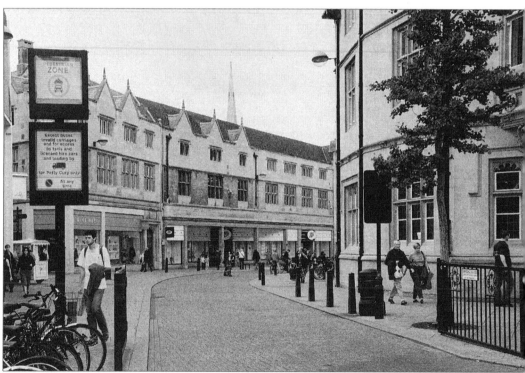

Sidney Street, 2000. Petty Cury has been reduced in length by the continuation of the Boots redevelopment to the corn The width of this section of Sidney Street is clearly not historic. The old post office building was another victim of Lion Ya but by 1939 it had moved out to the current premises in St Andrew's Street. Prior to demolition it was occupied by t Ministry of Pensions and County Council's Welfare Foods Distribution Centre. (*Tony Jedrej*)

ney Street, 1950. The store in the left background
ɔshua Taylor's, which moved to Cambridge in 1861
n Ely and gradually took over the shops in this area
il almost all the island site backing on to Market
sage was occupied. Accommodating traffic in historic
ns was a major postwar problem and small-scale road
lening schemes had only a minimal and local effect.
mbridgeshire Collection)

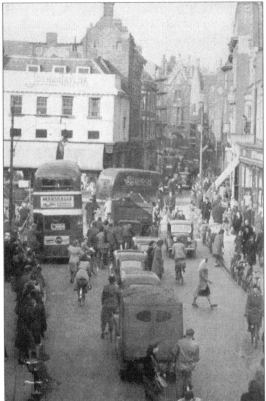

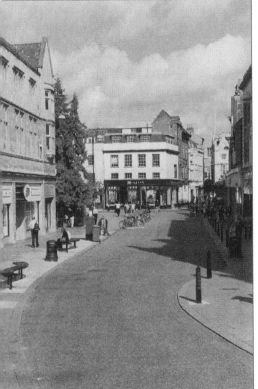

Sidney Street, 2000. Joshua Taylor's closed in 1991 and
went the way of most Cambridge-based department stores
as the national chain stores moved into the high streets
of Britain. Retail nostalgia hits us all when we recall our
favourite shops of yesteryear but our Cambridge household
names were once the newcomers and themselves ousted
what were then old favourites. (*Tony Jedrej*)

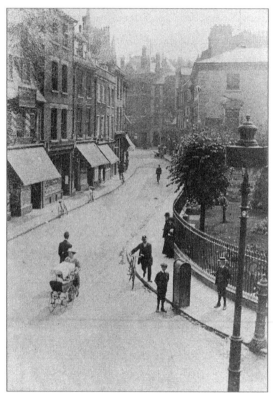

Sidney Street, 1910. To the right is the railed churchyard of Holy Trinity. The shops to the left have been rebuilt and set further back from the road over the years. In 1910 it seems you could park your bike at the kerbside outside the shops and still find it there when you came out. (*Cambridgeshire Collection*)

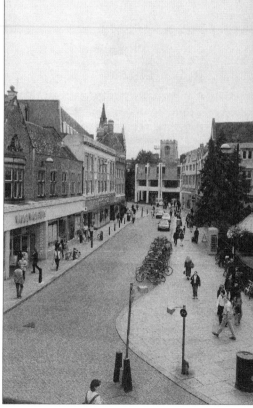

Sidney Street, 2000. This picture was taken through the upstairs windows of one of the modern shops in the former Joshua Taylor's building. Woolworth's, Marks & Spencers, Boots and Sainsbury's had all arrived in the town by the 1930s and gradually took over this part of Sidney Street. Woolworth's extended its property in 1960 as did Boots, with its Ketton stone facing to Holy Trinity. The local firms couldn't compete and shops like Coads clothing and Stiles confectionery were forced out or, like Millers Music, moved to other parts of the town centre when Marks & Spencer expanded. (*Tony Jedrej*)

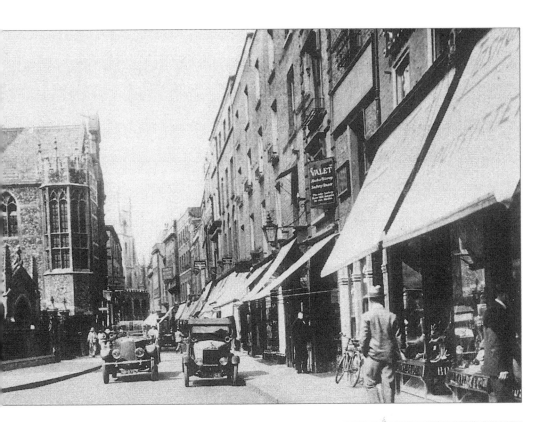

Above: Market Street, 1930. Originally called Shoemaker Row or Cordwainer Street, this was the home of Eaden Lilley, another famous Cambridge department store which had been trading in the street since the mid- eighteenth century. Sadly, despite a valiant refit and modernisation, it too succumbed to the pressures of competition and closed in 1999. On the left is the Henry Martyn Hall, commemorating its benefactor who was an evangelical missionary with the East India Company. The hall was limited in its use to religious and educational events – no politics or entertainment! *(Cambridgeshire Collection)*

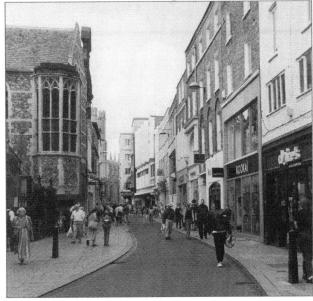

Market Street, 2000. The building line has altered little; only the shop fronts have changed to follow modern trends. When Eaden Lilley 'downsized', it made space for a new W.H. Smith store. The intention had been to keep the old frontage, but during refurbishment it was found to be in a dangerous condition and had to be removed. *(Tony Jedrej)*

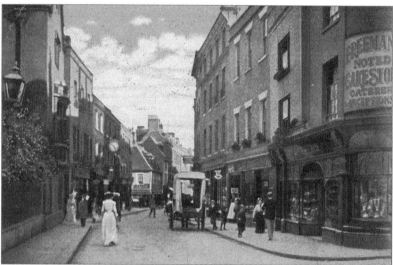

Sidney Street, from Green Street junction, 1907. This photograph is reminiscent of the bygone, genteel age shopping when the custom had the purchases sent rou to his or her house. The shops included Johnson – tailors, Moore – tobacconis Stockbridge – furniture, Freemans – cakeshop (take over by G.P. Hawkins), Galloway & Porter – books (it still remains in the street) and Otto Wehrle – watchmaker and jeweller, whose relative we have already encountered at Hyde Park Corner. *(Cambridgeshire Collection)*

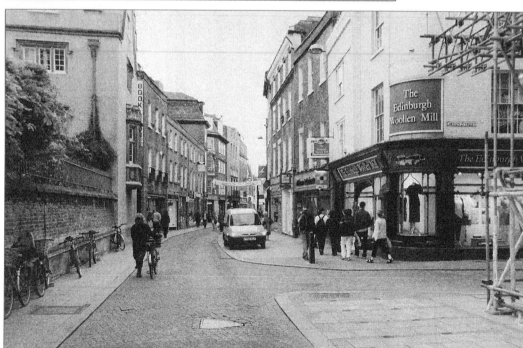

Sidney Street, 2000. Little would appear to have changed except for the redeveloped buildings in the far distance at t junction with Sidney Sussex Street. Sidney Sussex College, in the left foreground, is noted as the home of Oliver Cromwe head. Local lad Cromwell, ex-student and former Cambridge MP, was dug up two years after his death and his body w placed on a spike on one of the London bridges. In a severe storm it fell off and after passing through a number of hands was given to his former college and buried in a secret place, known only to two people, one of whom is the master, to prote it from royalists. *(Tony Jedrej)*

Saints' Church, St John's Street, *c.* 1860. Originally
own as All Saints' in the Jewry or All Saints' by the
spital, this was a building unique in Cambridge because
the walkway under its tower. By the mid-nineteenth
ntury, because it had only 67 pews for 255 dwellings,
parishioners wanted to expand it but there was little
ce and any building works would have disturbed burials.
1864 All Saints' was demolished and a new church
lt on Jesus Lane. This has since closed and lies empty.
mbridgeshire Collection)

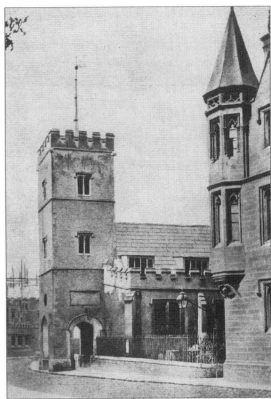

All Saints' churchyard, 2000. The tower to the right is part
of Whewell's Court, built when Trinity College 'jumped' the
street to build new accommodation, and Dr Whewell, Master
of Trinity College, himself in effigy looks down from the
corner. All Saints' churchyard was given a memorial cross
designed by Basil Champneys to commemorate the church.
He also designed the neighbouring School of Divinity. The
trees are now reaching maturity and almost totally screen
from view the charming local craft market which operates in
the grounds. (*Tony Jedrej*)

107

St Sepulchre's Church, 1811. Holy Sepulchre or the Round Church is one of the oldest buildings in the city. Little is known of its origins or of the order that built it, but it is reputed to date from around 1130 and to have been constructed on the site of another church, St George's. It remains one of the best-known non-collegiate buildings in Cambridge. (*Cambridgeshire Collection*)

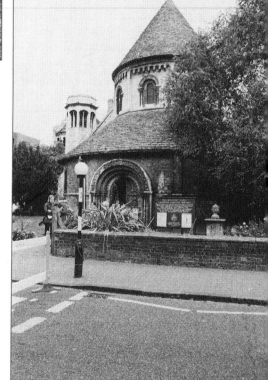

The Round Church, 2000. The restoration carried out in 1841 was criticised as somewhat severe and, as can easily be seen by comparison with the previous picture, totally altered the appearance of the building above the roof line, although the conical version is said to have been a reasonably accurate restoration. (*Tony Jedrej*)

...borsky's, Round Church Street, 1935. 'Count' Joseph ...borsky was barber to the Imperial Austrian Court ... came to Cambridge in 1879 because of the rise of ...ionalism in Austria. Victorian barbers cut hair but ...ay's practitioners are mostly stylists. The building to ... right is the University Union Society. *(...mbridgeshire Collection)*

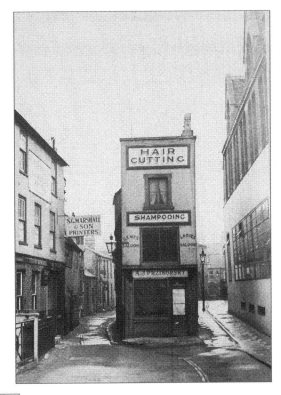

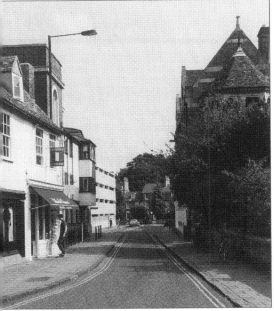

Round Church Street, 2000. Prizi's shop was cleared along with the rest of the buildings which made up Ram Yard to make an entrance for Park Street car park, which was built in 1962–3. Nearly forty years later this entrance to the car park became redundant with the closure of Bridge Street to private vehicles. (*Tony Jedrej*)

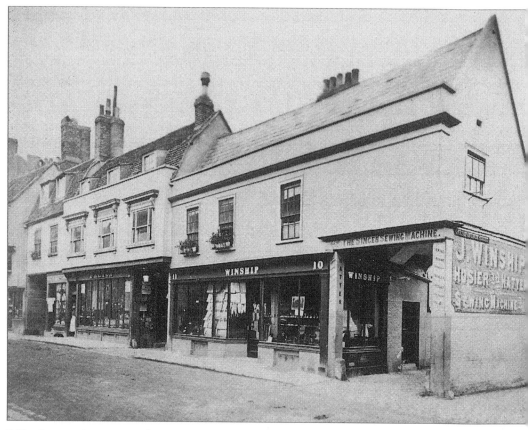

Bridge Street, at the junction with Round Church Street, 1870. The gable end and carriage drive had been removed by the 1930s, perhaps because the council took advantage of any opportunity to widen roads in order to cater for the growth car ownership. *(Cambridgeshire Collection)*

Opposite, top: Bridge Street, 1937. In the late 1930s St John's demolished most of the remaining buildings on the weste side of Bridge Street, including eighteen houses and shops, Warren's Yard, Sussum's Yard and Coulson's Passage to build new cycle shed and music school. The traffic lights are a gem. *(Cambridgeshire Collection)*

Opposite, bottom: Bridge Street, 2000. The range was restored in 1977 after much public controversy about its condition a received a conservation award. Jordan's Yard at the rear only survived in name and was completely taken over by mode buildings. *(Tony Jedrej)*

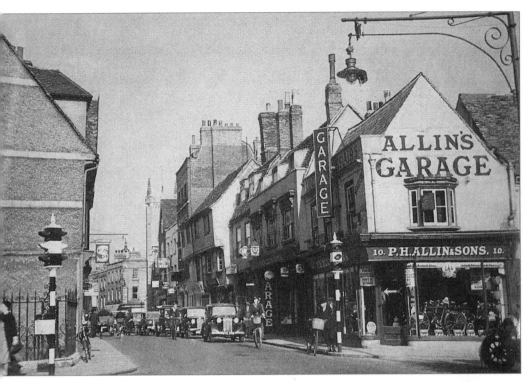

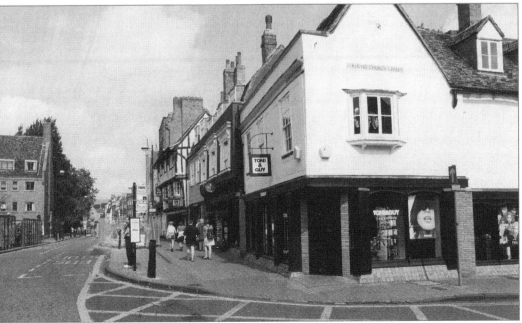

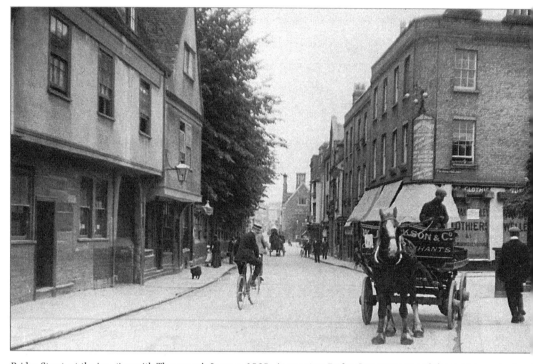

Bridge Street, at the junction with Thompson's Lane, *c.* 1930. At one time Bridge Street was one of the most important are of the town because of the river trade and the crossing. With the advent of the railway the economic centre of gravity shif towards the station and as a result many of the eighteenth-century buildings survived until the mid-twentieth century there was no need for nor enough profit in their replacement or major refurbishment. When the colleges eventually began expand into the town they found this kind of area an easy target. Thompson's Lane was named after a family who lived the area from 1520 to 1750. (*Cambridgeshire Collection*)

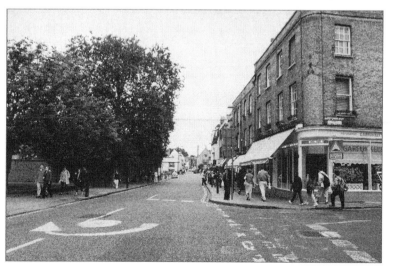

Bridge Street, 2000. The open view of the street we see today clearly a relatively modern one The pattern of development is similar to King's Parade in tha a leading college burst through into the street and cleared awa much of the town's heritage here. In 1863 St John's College began by demolishing seven houses to open the Master's Lodge to the street; the tree wa planted at a similar date. The council was acquiescent in the road widening process which was completed in 1937. The current view has now become the accepted one and any changes would probably be me with protests. (*Tony Jedrej*)

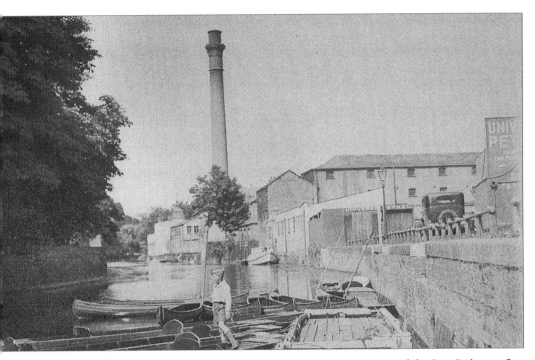

ayside, *c.* 1930. Cambridge's medieval crest carries three sailing ships and a representation of the Great Bridge to reflect e importance of Quayside to the town. Once the colleges had closed the hithes on the Backs, this became the hub of mbridge's river freight trade. The condition of the roads was so bad that it was quicker for a student to send his bags ound the east coast from London and up the Ouse and Cam than along the 60-mile journey by road. Steam barges placed horses and heavy goods such as corn, coal, wine and oil cake continued to come into Quayside. However, by 1900, e trade was reduced to turf, timber, beer and firewood. By the 1930s the river was a sleepy backwater, with pleasure boats d rowers the only craft to grace the Cam. The chimney is for the electricity power station in Thompson's Lane which sed in 1966. *(Cambridgeshire Collection)*

ayside, 2000. The river front has been totally built to accommodate high-quality flats and number of café bars and restaurants. The imney was demolished in 1982. However, the en view of Magdalene College is not historic. 1873 Magdalene demolished Kimbolton and lmon Lanes to reveal its newly restored south ont to the world. With the demise of the river ade and the construction of other bridges, the 14 as a bypass and the closure of Bridge Street all through traffic except public transport, e area has been given back to pedestrians. *ony Jedrej)*

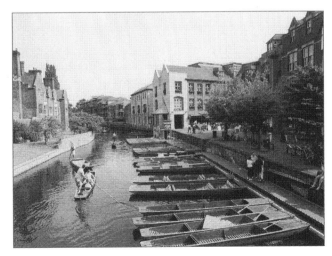

113

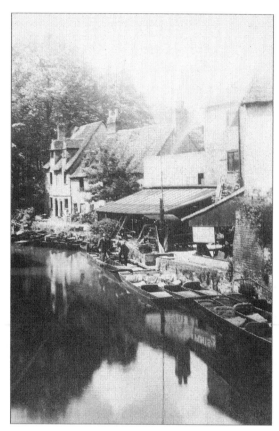

Fisher Lane, *c.* 1900. The conversion of the old riverside premises turned this range of picturesque cottages into a attractive punt station for Bullen's Boatyard. This picture was taken from the Great or Magdalene Bridge, made locally in 1823 from cast-iron. The earliest reference to a bridge on this site dates from 875 AD. (*Cambridgeshire Collection*)

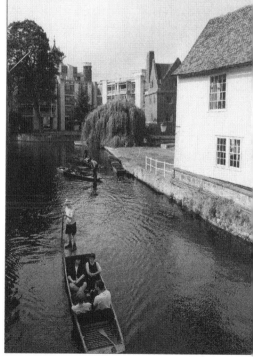

St John's College, 2000. The college 'jumped' the river in the sixteenth century but this site wasn't developed until the twentieth with the construction of the much admired Cripps Building in the 1960s. Fisher Lane was a casualty of the Magdalene development, along with a mustard and vinegar factory, and only the two buildings next to the bridge survived. (*Tony Jedrej*)

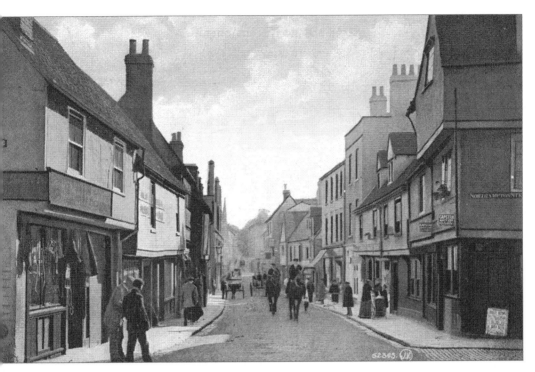

gdalene Street, 1905. This could have been Buckingham Street if the college of that name had not been refounded as gdalene in 1542. The view down the street towards the Great Bridge from the junction of Northampton Street and esterton Lane was ever under threat throughout the twentieth century, mainly from college expansions. Magdalene, the only llege to be founded north of the river, wanted to sweep away the range on the right and Edward Lutyens did complete the first ct of the plan, with Benson Court at the rear in the 1930s. Thankfully, the money ran out. *(Cambridgeshire Collection)*

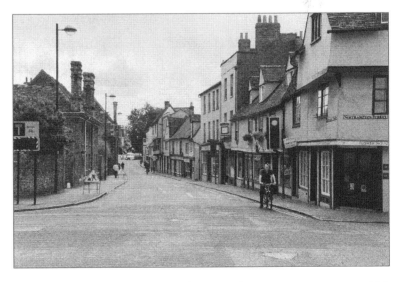

agdalene Street, 2000. In
e 1960s road engineers tried
here the college failed with
nother widening scheme but
is too was unsuccessful.
ne of the sixteenth-century
nge of buildings is the former
oss Keys Inn, the timber
mes carrying carvings or
rotesques' of devils with
er-large phalluses which are
d to advertise its trade as
brothel. However, in 1912
agdalene College did succeed
demolishing twelve houses to
eate a site for a new hall
nd a garden for the master.
ony Jedrej)

115

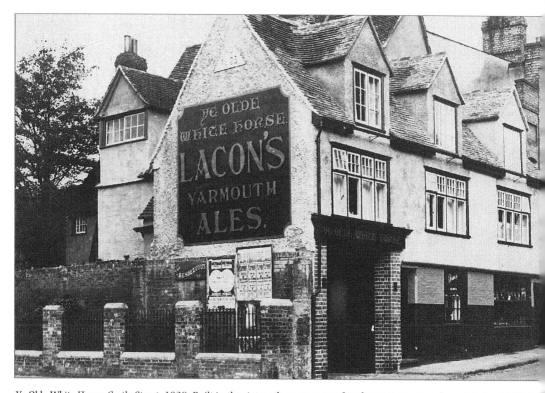

Ye Olde White Horse, Castle Street, 1930. Built in the sixteenth century as a farmhouse it was transformed in the 1600s int the White Horse. All the timber-framed walls are plastered and restoration work carried out in 1961 revealed a wattle an daub construction. Pine was used rather than oak. The wood may have been imported from the Baltic via King's Lynn ar sold at the international Stourbridge Fair in Cambridge. (*Cambridgeshire Collection*)

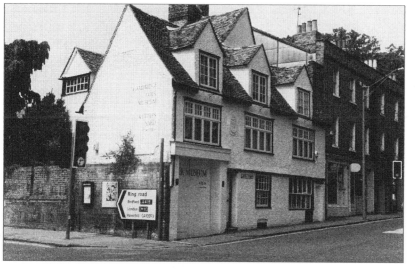

Folk Museum at the White Horse Inn, 2000. Northampton Street was, like many others, a victim of road widening and the timber yard that once stood alongside the inn was removed in about 1910. The White Horse is one of Cambridge's most important domestic buildings and it remains fully open to the public. Converted to a social history museum in 1936 it is well worth a visit. (*Tony Jedrej*)

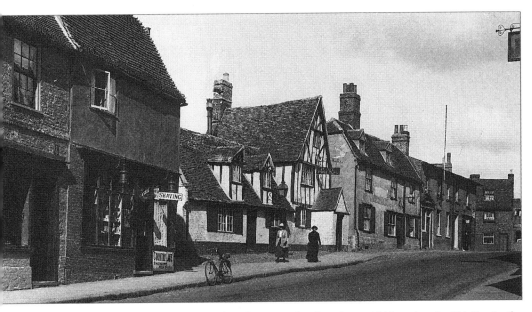

e Three Tuns, Castle Street, *c.* 1900. This ancient hostelry was said to be a frequent hiding place for Dick Turpin, the orious highwayman. It wasn't enough to save him or the pub, for like many of the timber-framed structures in the area vas patched and repaired at low cost over the years just to keep it going rather than to resolve serious structural problems. *mbridgeshire Collection)*

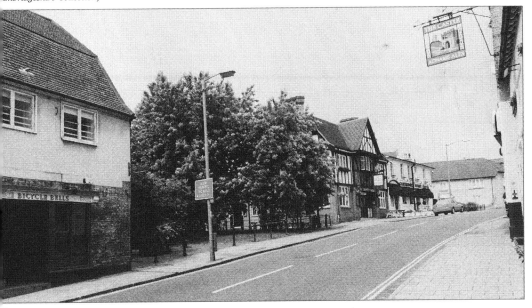

stle Street, 2000. The ultimate ignominy for the Three Tuns was that after demolition nothing replaced it. Today it seems conceivable that such a building could have fitted into such a small plot of land in front of Bell's Court. Next door the punty Arms was rebuilt in the 1930s, ironically in mock-Tudor timber-framed style. (*Tony Jedrej*)

117

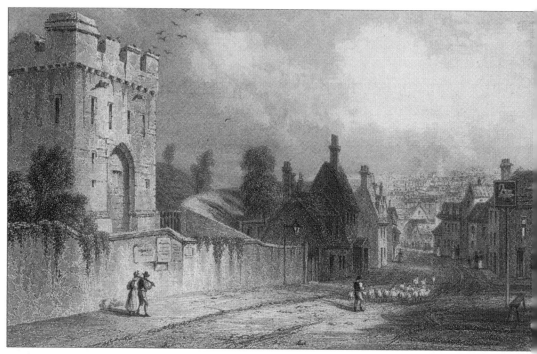

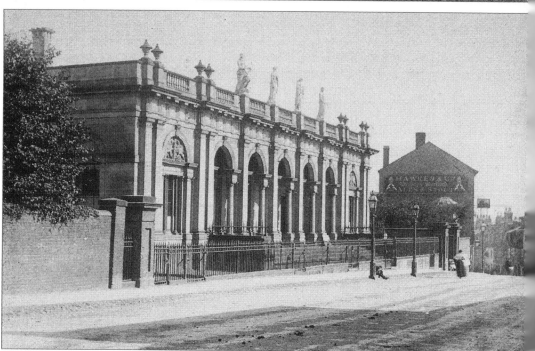

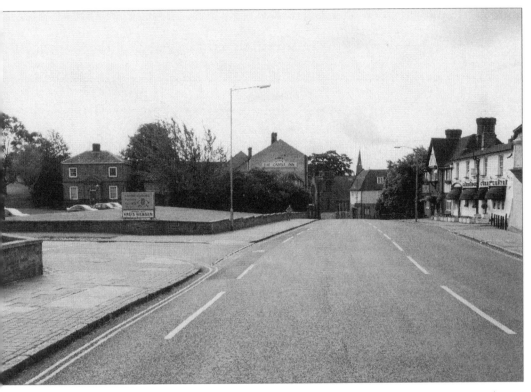

stle Hill, 2000. No mercy was shown to the Assize Courts when it was demolished and the site was grassed over and used
· carparking. The Castle Inn has survived the demise of its more illustrious neighbours. (*Tony Jedrej*)

posite, top: Castle Hill looking towards the Great Bridge, 1840. On the left is the Castle Gatehouse which was all that
mained of the once great fortification. William the Conqueror demolished twenty-seven houses to build his castle but
e major stone works were carried out by Edward I between 1283 and 1299. Henry VI gave the stone from the roofless
·eat Hall to King's Chapel and the recycling process continued with applications to Elizabeth I for stone for Sawston Hall,
amanuel and Magdalene Colleges and Great St Mary's Church. Although Elizabeth stipulated that the walls should remain,
1606 even they were gone and only the gatehouse and the gaol remained. (*Cambridgeshire Collection*)

posite, bottom: Castle Hill, *c.* 1900. Built in 1842 for the Assize Courts and used as a Shire Hall, this fine building with its
ur statues depicting Law, Justice, Mercy and Power was demolished in 1953. The distinctive gable end of the Castle Inn is a
miliar landmark. (*Cambridgeshire Collection*)

119

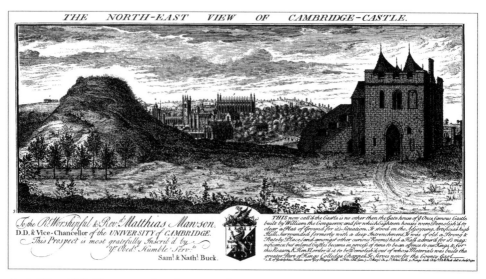

Castle Hill, *c.* 1900. The motte and gatehouse are all that remains of the Great Castle, although the castle was not so great that they wanted to keep it. In any event Cambridge is a relatively peaceful place and does not warrant fortifications. This drawing is of dubious accuracy as the motte should be much larger to be in scale and the view would not be visible from the back of the hill. The site is now overlooked by the massive Shire Hall built in 1931, which replaced the County Hall in Hobson Street built in 1913. This in turn replaced the Shire Hall of 1842 on Castle Hill, which replaced the Shire House of 1747 on Market Hill, which replaced the Shire House of 1572 on Castle Hill. . . . *(Cambridgeshire Collection)*

Castle Hill, 2000. Our tour ends where Cambridge began. Belgic tribesmen first looked out across the river and decided that this was a good place to settle. Unfortunately no pictures of this event are available. (*Tony Jedrej*)

Acknowledgements & Picture Credits

John Durrant is a Cambridge City Councillor, a former mayor and he chaired the Property and Planning Sub-Committees for some years. He is a local historian and has given hundreds of slide shows to community groups throughout Cambridge. He is the founder of Cambridge Futures, a partnership of academics, business and local authorities which examines planning options for change in the city and surrounding area and has been chair of the Cambridge & County Folk Museum.

Tony Jedrej worked for many years at the *Cambridge Evening News* before going freelance. He is the author of a best-selling book on Cambridge Cats, and an exhibition of his photographs has toured Japan. He is also a past winner of the British Press Photographer of the Year. Scottish born Tony resides in Cambridge and is married with a daughter, two sons and two cats.

I would particularly like to thank Gary Wooley and Catherine Watling from The Junction whose support, expertise and advice were crucial to the completion of this project.

My thanks also go to those who have contributed to this book, and in particular to: Chris Jakes, Local Studies Librarian; and the helpful and patient staff of the Cambridgeshire Collection, Cambridgeshire County Council; Cambridge City Council for photographs by Norman Mason-Smith; and Mr Douglas E. Daniels for the loan of an original Victorian photographers' catalogue which came from the stationery shop of Edwin Doo. I am grateful to all who write, photograph, research, save or support local history organisations and archives without whom we would not have the wealth of material and ideas upon which we have drawn.

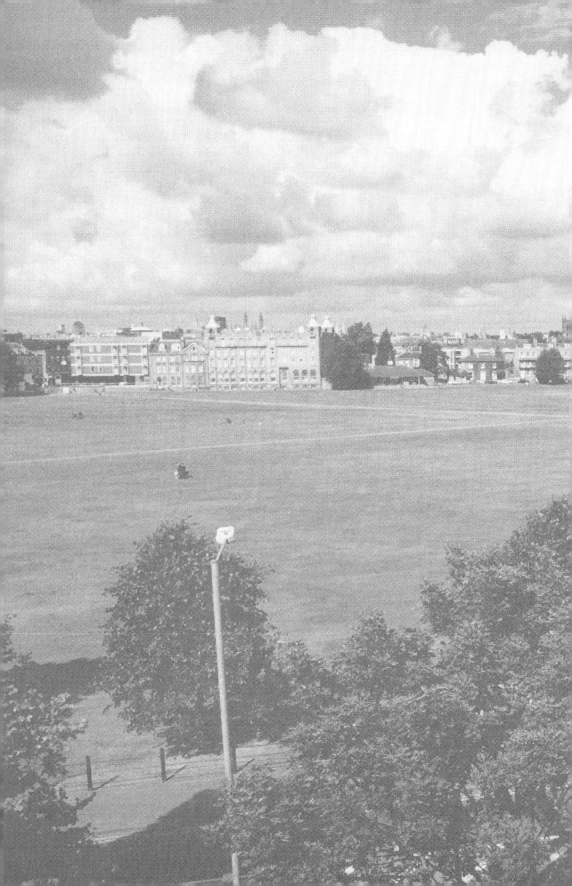

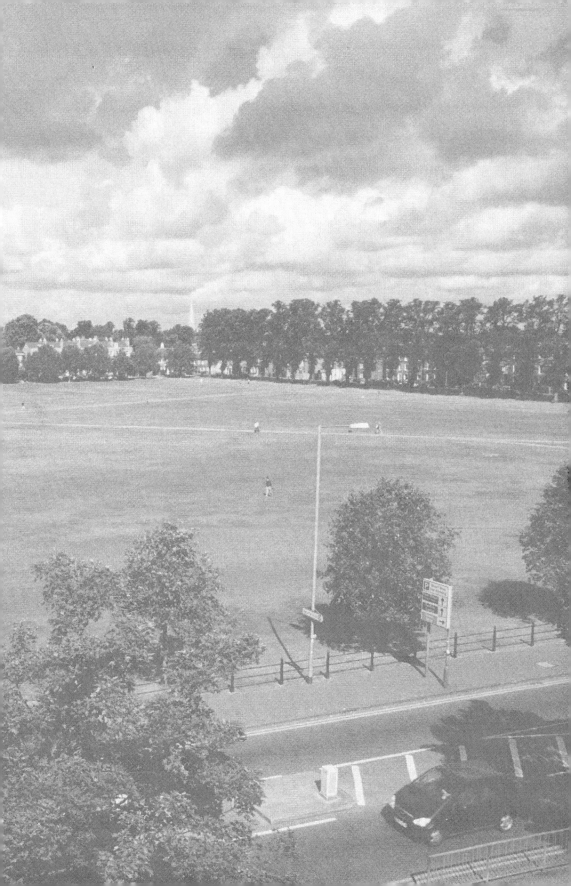